IMAGES
of America

BROOKFIELD AND ELM GROVE

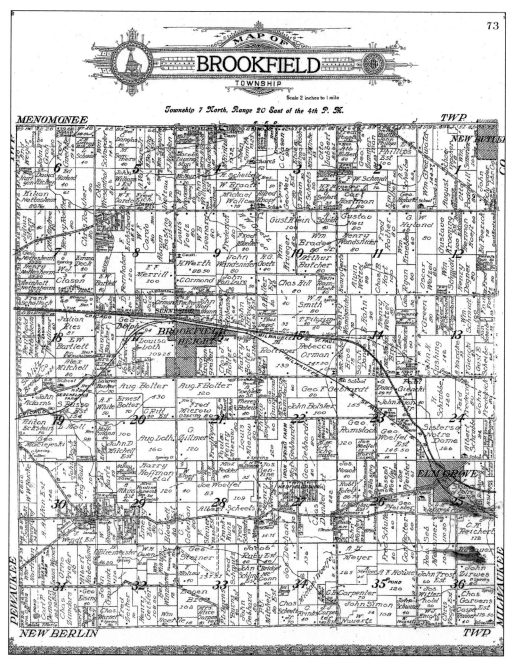

PLAT MAP OF BROOKFIELD TOWNSHIP, 1914. The above map will enable the reader to identify the exact location of each photograph presented in this book. The captions for many photographs presented in this work provide an identifying town section number corresponding to the numbers shown on the map. The map was published by George A. Ogle and Company in Chicago in 1914. (Courtesy of Waukesha County Historical Society and Museum.)

On the cover: **THE SVEHLEK FARM, C. 1914.** Posing in front of the Anton Svehlek family's large barn, from left to right, are brothers Frederick, Amil (an uncle), George, and William. (Courtesy of Larae Svehlek.)

IMAGES of America
BROOKFIELD AND ELM GROVE

Thomas Ramstack

ARCADIA
PUBLISHING

Copyright © 2009 by Thomas Ramstack
ISBN 978-0-7385-6070-0

Published by Arcadia Publishing
Charleston, South Carolina

Printed in the United States of America

Library of Congress Control Number: 2009920368

For all general information contact Arcadia Publishing at:
Telephone 843-853-2070
Fax 843-853-0044
E-mail sales@arcadiapublishing.com
For customer service and orders:
Toll-Free 1-888-313-2665

Visit us on the Internet at www.arcadiapublishing.com

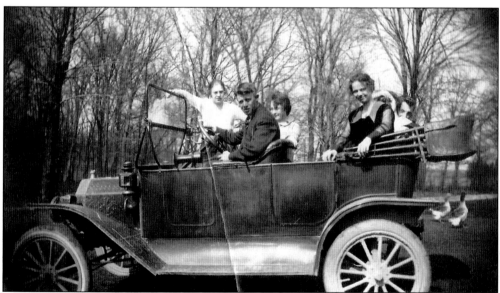

TOURING CAR, 1914. Sitting in the Phillips family's new 1914 Ford Model T touring car from left to right are (front seat) William, Mary (mother), and Caroline Phillips; (back seat) Helen and Amanda Phillips, along with Tony Neuman. They are on their way to visit Helen's fiancé in Elm Grove. Notice the lamps in front of the window and the car horn attached to the driver-side door. (Author's collection.)

CONTENTS

Acknowledgments		6
Introduction		7
1.	Immigrants in Town	9
2.	Success in Farming	21
3.	A Great Conflagration	47
4.	The Tornado of August 16, 1907	59
5.	The Village of Elm Grove	69
6.	The Tornado of May 31, 1914	81
7.	Elm Grove Fair	105
8.	The End of an Era	121

Acknowledgments

To make a project such as this achieve a qualitative state, it takes the assistance of many people. I would primarily like to thank the many individuals, families, and institutions that entrusted me with a great assortment of wonderful family photographs, which will now, through the efforts of Arcadia Publishing, be available to area residents in a structured format to enjoy for years to come.

The Elmbrook Historical Society provided constant support throughout this project. The society allowed me access to its photograph archives where new and exciting images not previously published were discovered. I would like to express my gratitude to Arline Kirkham, who provided me with three large file boxes full of local historical accounts, newspaper clippings, documents, and rare photographs. Finally, I would like to thank my son Sam Ramstack, without whose technical computer skills this book could not have been completed.

I would like to dedicate this work to the many individuals and families who literally risked life and limb to organize and develop what was referred to as the township of Brookfield in the earlier years. Just imagine the assortment of struggles many of these families were forced to endure—terrible storms, overdue farm mortgages, wars, plagues, terrible diseases, three major economic depressions, spousal abuse, awful droughts, drenching rains, alcohol abuse, isolation, and much, much more. They worked harder than many today are really capable of understanding. But they survived, most of them, through an incredible sense of endurance, resiliency, humor, and faith.

In July 2008, I had the pleasure to visit with 91-year-old Gilbert Dechant, who took the time to share his recollections of being a young man growing up in Brookfield. He talked about the hard work and sacrifices, but then he startled me with a teary-eyed remark, "You know, I miss those days and all our neighbors who were such good friends. I really miss them!" Mr. Dechant passed away on September 26, 2008.

INTRODUCTION

The book title describes a history of the city of Brookfield and the village of Elm Grove. However, this book is designed to encompass all the municipalities combined within the old township of Brookfield in Waukesha County, the present-day town of Brookfield, and the village of Butler.

There have been two important photograph studies of Brookfield and Elm Grove published in recent years. The first, *Historic Landmark Tour: Brookfield & Elm Grove, Wisconsin*, published in 1991 by Arline Kirkham, evolved out of a tour of historic local buildings and farmsteads organized by Kirkham and others during the 1980s. One of the greatest accomplishments of the second work, *Following the Trail*, by Stephen K. Hauser and Jean R. Stackpole, published in 1998, was in adding visual attention to several dynamic residents from Brookfield and Elm Grove's more recent past. In this third visual account, *Brookfield and Elm Grove*, the author discovered a wide assortment of wonderful, previously unpublished images that hopefully will entertain the reader with early-day visions of local railroads, baseball, transportation, ethnic groups, farm work, schools, churches, family gatherings, roads, and farmsteads. The primary emphasis was placed on securing an assortment of visual images from Brookfield and Elm Grove in its earliest years, the 1850s to early 1900s. Most significant is a pattern of images displaying everyday people. Close-up images were coveted. One can read a lot about people by looking at their faces, their smiles, their wrinkles, their youth, their thoughtfulness, and their sadness or joy, and by looking close enough, something of their true character might be seen as well.

Much of the content for the captions was taken from information given by the individuals who shared their images. Content also came from a large collection of local historical newspaper accounts that the author has been gathering for several decades. The great majority of these quotations are substantially abbreviated due to their length. The author also would like to apologize in advance for any identification mistakes that might be related to family names appearing in this work. The author went out of his way to get the names right, but, as no work is perfect, he is certain this one will not be either.

At first notice, the people seen in these images might appear peculiar in their seemingly strange dress and overall appearance. Modern life experiences are vastly different than theirs.

Do not be fooled. Local residents today might have more in common with their early-day neighbors than one might suspect. Look at how many of the same social issues just mentioned remain today. Moreover, they experienced the same internal emotions of depression, sadness, foolishness, joy, grief, silliness, fatigue, exhilaration, love, contentment, despair, and hope in exactly the same way people experience them today. Furthermore, people today might want to take a moment to appreciate the strengths and humanness of these families. They set the

foundation for present-day inhabitants of Brookfield and Elm Grove to possess the possibilities of living extraordinary lives.

One

IMMIGRANTS IN TOWN

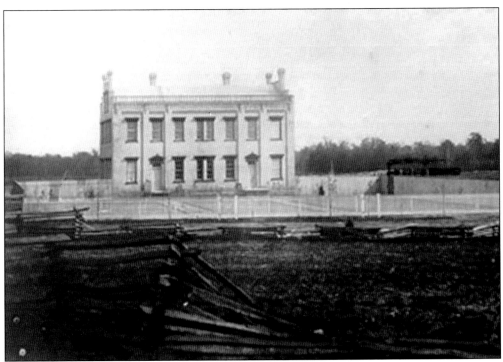

A CATHOLIC ORDER OF SISTERS, C. 1859. By the 1830s, Brookfield had become populated by people with quite divergent traditions, including the School Sisters of Notre Dame, led by Mother Caroline Friess, who came to Wisconsin from Bavaria. In this image is an extremely rare view of the actual planking on Watertown Plank Road just beyond the fallen fencing as well as an early view of a train run by the Milwaukee and Mississippi Railroad, which later evolved into the Chicago, Milwaukee and St. Paul Railroad. (Courtesy of School Sisters of Notre Dame.)

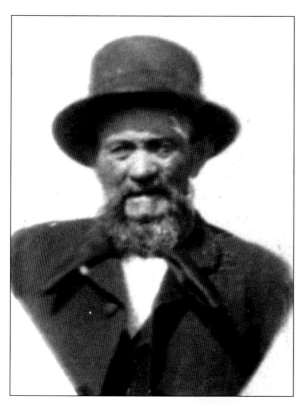

HEINRICH MIEROW, C. 1856. This is one of the earliest identifiable photographs of a resident from the town of Brookfield. Heinrich Mierow was born in Maderow, Mecklenburg (Germany) in 1835. During the 1860s, Heinrich and his wife, Sophia Wilhelmina Kruse, born in Harmshagen, Mecklenburg, immigrated to Wisconsin, first settling in Milwaukee, and then Wauwatosa. In 1892, a son, Henry Mierow, purchased an 80-acre Brookfield farm (section 21). The father, Heinrich, passed away while residing on his family's Brookfield farm in 1905. (Courtesy of Arline Kirkham.)

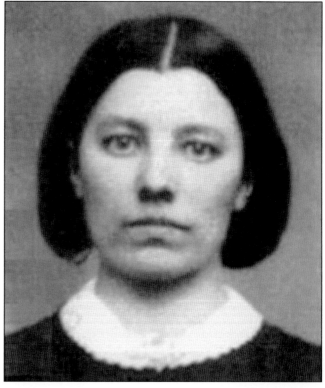

MOTHER OF LAURA INGALLS WILDER, C. 1858. One of Henry and Charlotte (Tucker) Quiner's seven children, Caroline, was born on the family's Brookfield farm (section 31) on December 12, 1839. As an adult, Caroline married Charles Ingalls, and it was their daughter Laura Ingalls Wilder who achieved wide acclaim for her *Little House* series of books. (Courtesy of Charles Joseph Haig.)

EZRA CHAPIN, C. 1852. The *1907 Memoirs of Waukesha County* states, "In the fall of 1842, Ezra Chapin, of Prattsburg, Steuben County, N.Y., and his wife, Mary Ann (Davis), emigrated to Wisconsin. Mr. Chapin [shown in this illustration] purchased one hundred and sixty acres of government land in Brookfield [section 21], of which one acre had been broken and had a growth of potatoes on it." (Courtesy of Waukesha County Historical Society and Museum.)

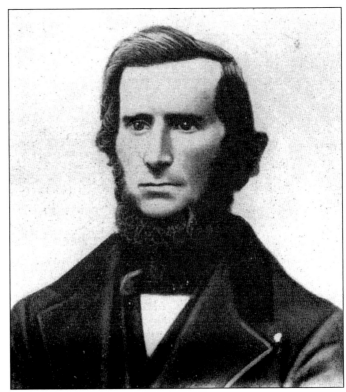

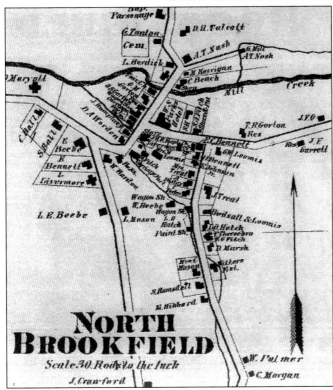

BROOKFIELD, NEW YORK. The families of Nathan Farr, John Fosturing, Charles Leland, David Merrill, S. G. M. Putney, Moore Spears, Jacob Stamm, Dr. Harmonious Van Vleck, and Gideon Wales from Madison County, New York, arrived in the town during the 1830s. They brought with them the name of one of their own townships to name their new town here in Wisconsin—Brookfield. This image comes from the 1875 *Atlas of Madison County, New York*. (Courtesy of the Historic Photograph Collection/Milwaukee Public Library.)

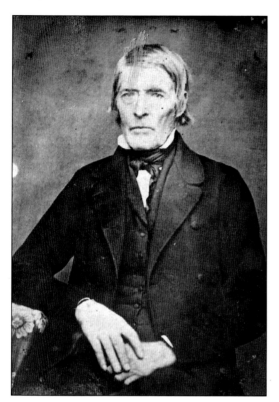

AUGUST BLODGETT, C. 1858. A miller from Buffalo, New York, August Blodgett (1787–1861) brought his family to Brookfield Township in 1843. The Blodgetts were among the earliest New York families to arrive in town. Blodgett purchased a Brookfield farm (section 29), which was then run by the Blodgett family for over 100 years. (Courtesy of Isabel Wray.)

LUCY (PRATT) BLODGETT, C. 1858. August Blodgett and Lucy Pratt (1791–1868) were married on September 23, 1791. The couple had one son, Chester Blodgett, who was born at Rushville, New York, in 1827 and came with his parents to Wisconsin. The younger Blodgett took over operation of the family farm with his father's passing in 1861. (Courtesy of Isabel Wray.)

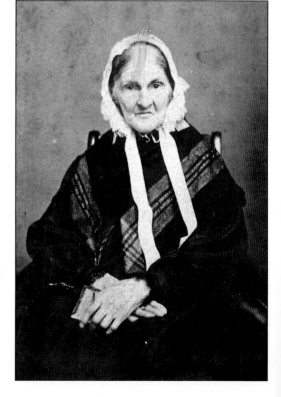

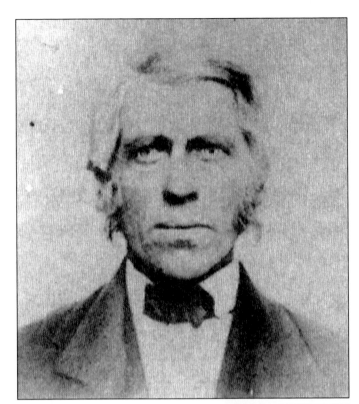

JOHN DIXON, C. 1877. A large colony of families from Lincolnshire County, England, settled in Brookfield (section 15) during the 1850s. Included among them were several farmers, a blacksmith, a saw- and gristmill operator, and a boot and shoemaker. In 1855, the settlement built a Methodist Episcopal church. All of its original members, including John Dixon (shown here), were English. (Courtesy of Arline Kirkham.)

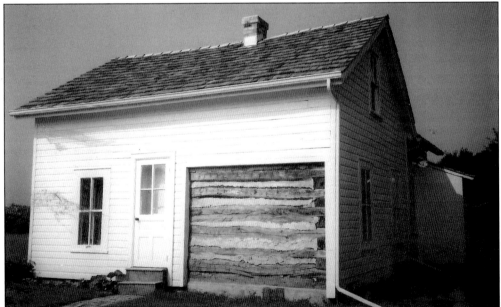

WILLIAM T. DONALDSON HOME, 1991. William T. Donaldson, his wife, Ann, and their six children, all emigrants from England, purchased a 40-acre Brookfield farm (section 7) in 1845. The presentation of the log structure underneath the home's siding is significant because in the 1830s, hundreds of Brookfield homes were constructed of log. Frame or brick homes did not become common in the town until late in the 1860s. (Courtesy of Arline Kirkham.)

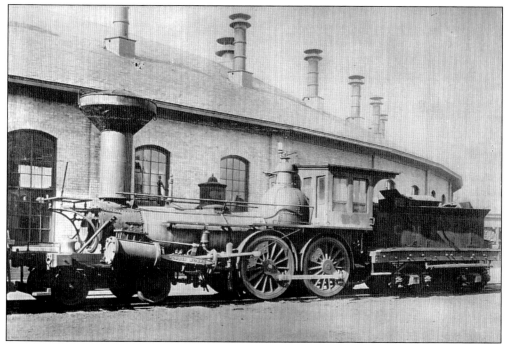

THE BOB ELLIS, C. 1873. Hundreds of Brookfield residents lined the tracks on February 25, 1851, as the *Bob Ellis*, "the first train that ever turned a wheel in Wisconsin," passed through the town for the first time on its way from Milwaukee to Waukesha. The railroad's initial rate table provided stops at Elm Grove, Dixon's Road, Power's Mill, and Tews Road—all in Brookfield. (Courtesy of Waukesha County Historic Society and Museum.)

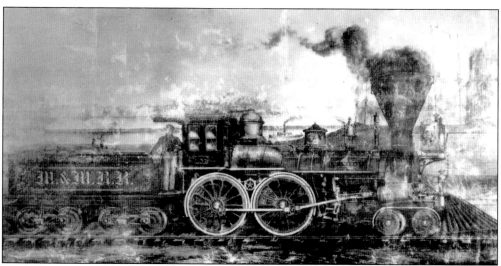

MILWAUKEE AND MISSISSIPPI RAILROAD, C. 1851. Here is an illustration of one of the earliest locomotives of the Milwaukee and Mississippi Railroad. On June 4, 1858, the *Milwaukee Sentinel* presented the following account of flooding along the train's route in 1858: "We made good time till we arrived at Brookfield Junction, 14 miles from Milwaukee. We learnt that there was serious trouble ahead—bridges gone, track flooded, and portions washed away." (Courtesy of Wisconsin Historical Society, WHi-25353.)

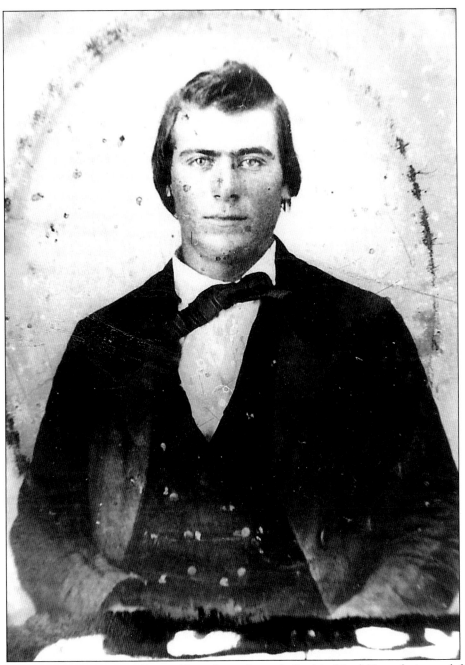

JOHN NETTESHEIM, C. 1862. Reiner Nettesheim, his wife, Sophia (Fuss) Nettesheim, and their four children emigrated from Friesheim, Germany, to Wisconsin in 1848. Upon their arrival, the family purchased a Brookfield farm (section 7). With Pres. Abraham Lincoln's call for troops at the start of the American Civil War, one of the Nettesheim's sons, John, enlisted in Company H, 28th Wisconsin Infantry. Family historian Gene Nettesheim wrote, "After a very bad winter at Helena, Arkansas, Corporal [John] Joseph Nettesheim came down with Typhoid Malaria fever, as so many others did, and died May 23, 1863. He was buried near Helena, Arkansas and later his body was moved to the Memphis National Cemetery." (Courtesy of Gene Nettesheim.)

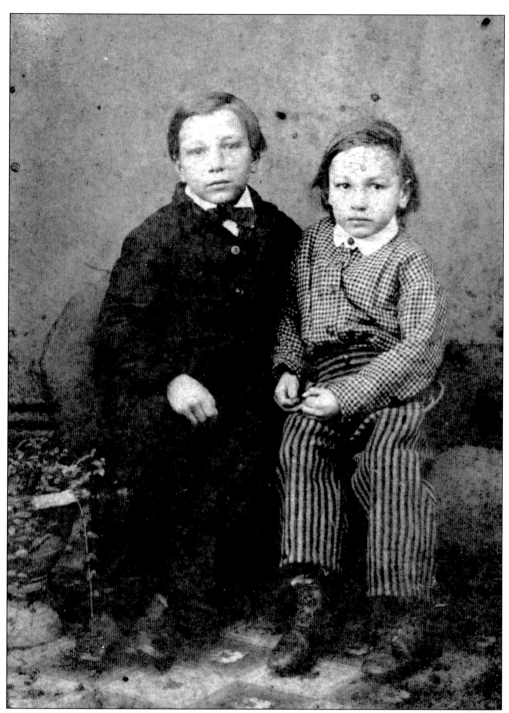

THE BEHEIM BROTHERS, C. 1864. The Anton and Theresa Beheim family emigrated from Bavaria to Wisconsin during the 1850s. Soon thereafter, Anton purchased a Brookfield farm (section 21). By 1870, he had died. Theresa and her five children, Anton, Nicholas, Christina, Bertha, and Emma, then maintained the farm. In this view, brothers Anton (left) and Nikolas Beheim pose for the photographer. (Courtesy of John Schoenknecht.)

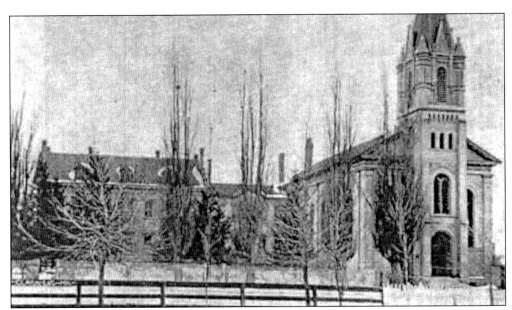

A NEW CATHOLIC CHURCH. During the 1860s, Brookfield's Bavarian (German) Catholic congregation abandoned its log structure (section 23) and built a new brick church on the grounds of the School Sisters of Notre Dame at Elm Grove in 1868. The *Milwaukee Sentinel* reported on November 13, 1868, "The new Catholic church at Elm Grove will be formally dedicated next Sunday morning by Bishop Henni. The cemetery will be consecrated and the bell blessed." (Courtesy of School Sisters of Notre Dame.)

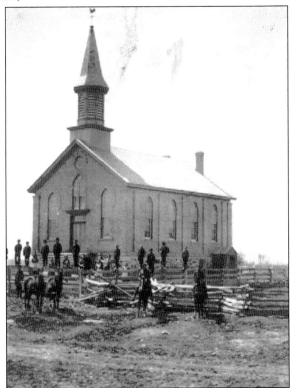

TRINITY EVANGELICAL CHURCH, 1871. The *Brookfield News* reported on July 5, 1956, "The church board purchased the bricks and members did the hauling and most of the mason work for Trinity Church [section 4]. The cornerstone was laid on May 1, 1870." This image appears to show church members posing atop the posts after completing a new fence around the church in 1871. (Courtesy of Bob Rohrig and Rich Wullscheger of Trinity United Church of Christ in Brookfield.)

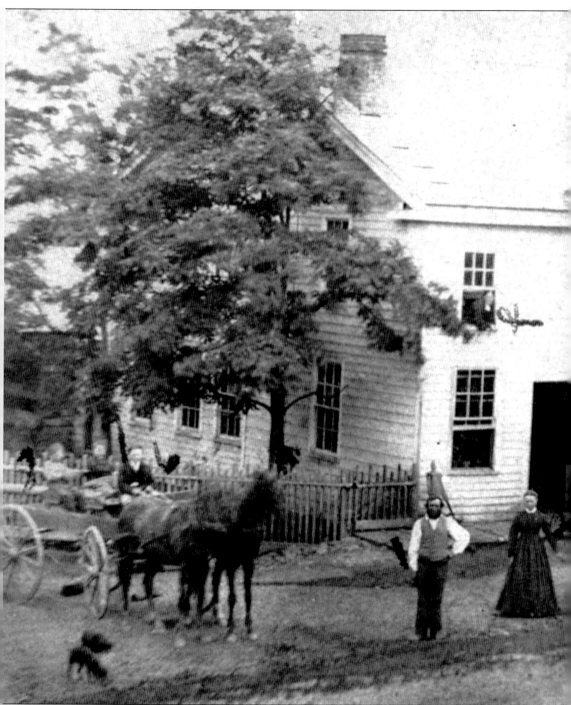

THE PHOENIX HOTEL, C. 1867. The John Hoffman family, emigrants from Canton Thurgau, Switzerland, arrived in Brookfield in 1849 and soon after purchased the Phoenix Hotel (section 28) on Watertown Plank Road. Posing for this early view, from left to right, are family members Henry, Ferdinand, John, John Sr. (father), Sophia, Ida, Eliza, and Caroline. Anna (mother) is in the second-floor window, and an unidentified man is leading the horse cart at right. The

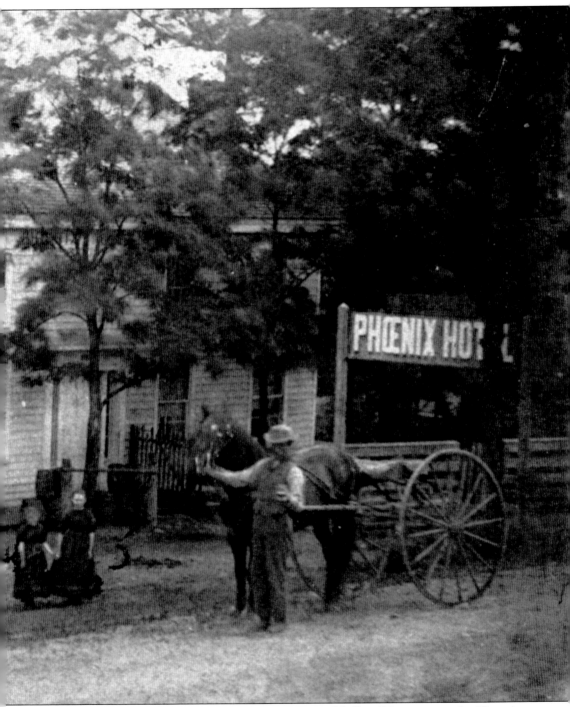

Waukesha Freeman reported on October 4, 1870, "A grand ball will be given at the Phoenix Hotel, in the town of Brookfield, on the Watertown plank road, and the undersigned takes pleasure in respectfully inviting to this occasion all people fond of dancing. An excellent music band is engaged." (Courtesy of John Schoenknecht.)

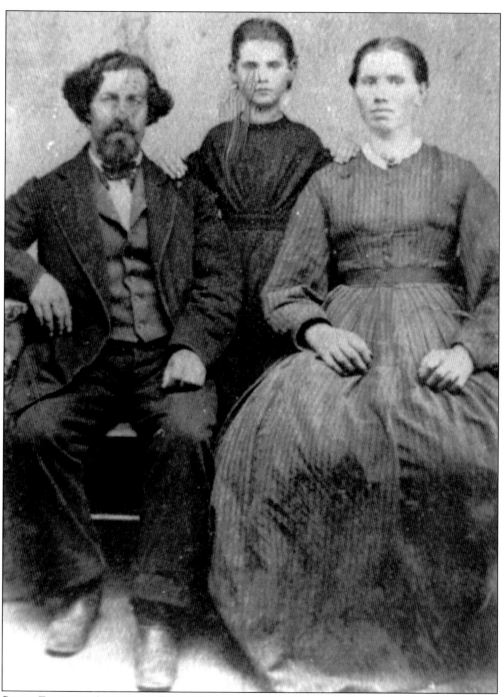

SWISS FAMILIES ARRIVE IN BROOKFIELD, C. 1871. Wisconsin Swiss historian Maralyn A. Wellauer wrote, "Christian Winzenreid, born 1797 in Bern, and his wife, Susanna, born about 1828, were the parents of Christian, Benedict, and Samuel Winzenreid. Christian and Benedict immigrated together into the town of Brookfield [section 32], in November, 1850." This image shows Benedict Winzenreid and his wife, Anna Kunigunda (Ramstöck), along with their daughter Julia Anna. (Courtesy of Elaine Moss.)

Two
SUCCESS IN FARMING

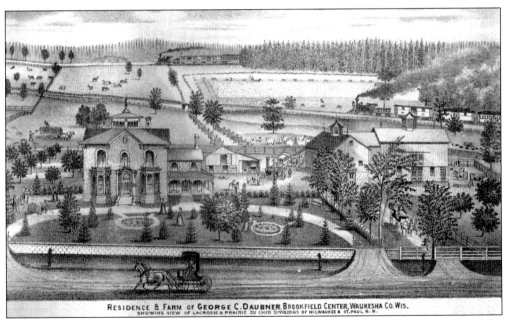

THE GEORGE H. DAUBNER FARM, 1878. For those who stayed, Brookfield became one of the better agricultural towns of Waukesha County. By the 1870s, Brookfield's farms were producing wheat, wool, barley, and butter in record amounts. This view of the George H. Daubner farm in Brookfield (section 15) presents an idyllic farm scene. In the background are both lines of the Milwaukee and St. Paul Railway. This image comes from the 1878 *Historical Atlas of Wisconsin*. (Courtesy of Waukesha County Historical Society and Museum.)

IONA BLEIMEISTER, 1879. In 1881, Iona Bleimeister, age 28, and her new husband, Henry Bleimeister, age 27, ran a 58-acre Brookfield farm (section 32) at a settlement called Blodgett along Watertown Plank Road at the western confines of the town. (Courtesy of John Schoenknecht.)

REV. SIMON WOELFEL, C. 1881. The son of John and Marianna Woelfel of Elm Grove (section 23), Simon Woelfel was the first ordained native-born Catholic priest from Waukesha County. He offered several masses at the Visitation of the Blessed Virgin Mary Catholic Church at Elm Grove during the 1880s, although he was never assigned to this parish. (Courtesy of Roger and Marion Woelfel.)

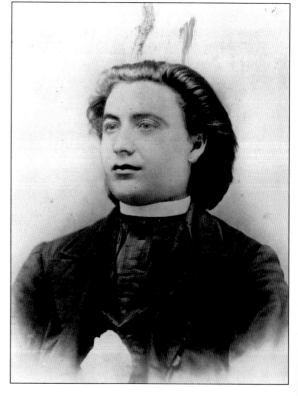

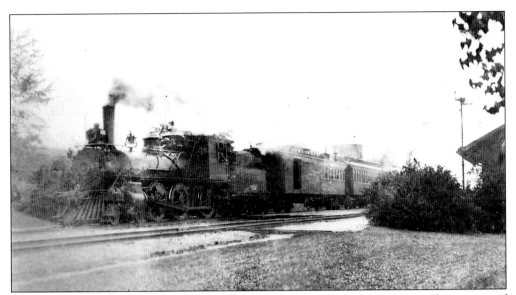

AN EARLY-DAY BROOKFIELD STORY, C. 1880S. On March 21, 1912, Harry Showerman of Brookfield (section 17) presented this first-person account of a terrifying sled ride he took down Brookfield Road toward Brookfield station in the 1870s: "He [Harry Showerman] seemed to be dropping through air, so swiftly he came. Roar!—the engine passed, almost striking the boy's feet as they extended out behind his sled. The postmaster, George Brown, yelled to Shed Putney, 'He slid down the hill, and if he missed the cow-catcher of the La Crosse train by six inches my name isn't George Brown.'" (Courtesy of Elmbrook Historical Society.)

THE LEE FAMILY, C. 1885. In this image, from left to right, are Emma, Edward (father), Sarah (mother), and Anna Lee strolling across a field on their Brookfield farm (section 17). In 1923, longtime Brookfield resident George E. Robinson recalled, "I remember Ed Lee best as one of the Lee & Crossman string band who furnished the music for most of the parties held at that locality." (Courtesy of Craig Black.)

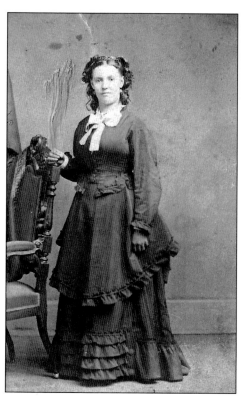

AUNT HENRIETTA "HATTIE" BEHLING, c. 1885. The *Waukesha Freeman* reported on October 3, 1889, "Mrs. Henrietta Behling of the town of Brookfield suffered a sad accident near the station Tuesday. Mrs. Behling thought the station was reached and attempted to alight, when she fell and was caught under the wheels. She was taken out as promptly as possible and Dr. Philler of Waukesha summoned. He found one arm crushed so badly that amputation was necessary above the elbow." (Courtesy of Evelyn J. Nicholson.)

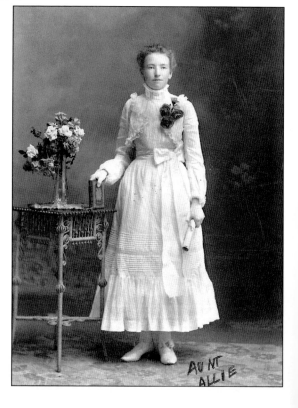

ALICE BEHLING, c. 1900. Albert and Henrietta "Hattie" Behling owned a Brookfield farm (section 13) during the 1880s. Despite the loss of her left arm in the train accident, she raised three children—Alice, Edith, and Herbert. Posing for the photographer is daughter Alice at what might be her confirmation. (Courtesy of Evelyn J. Nicholson.)

GRANT SHOWERMAN, C. 1923. Born on a Brookfield farm (section 17) in 1870, as a young man, Grant Showerman left the farm to attend the University of Wisconsin and went on to earn the Cavalier of the Crown of Italy award for his translation of classic Latin text. In 1916, he wrote *A Country Chronicle*, a semiautobiographical account of his childhood days in Brookfield. (Courtesy of University of Wisconsin Digital Collection.)

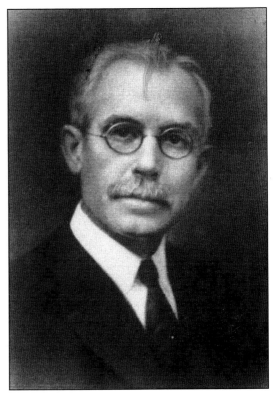

EDWARD COKE, C. 1885. During the second half of the 19th century, Edward Coke ran a Brookfield farm (section 21). The Coke family was somewhat unique in that he, his wife, Mary, and at least three of their children were deaf and mute. During the decade of the 1870s, three Coke children—Ella, Fred, and William—were all enrolled at the Institute for the Deaf and Dumb at Delavan. (Courtesy of Evelyn J. Nicholson.)

HARRY BLEIMEISTER, 1888. At age two, Harry Bleimeister, the first child of Henry and Iona Bleimeister of Brookfield (section 32), had his photograph taken at a Milwaukee studio. Dressing young boys in skirts and allowing their hair to grow long were common practices on Wisconsin farms during the 19th century. Boys were not typically dressed in pants until the age of four or five. (Courtesy of John Schoenknecht.)

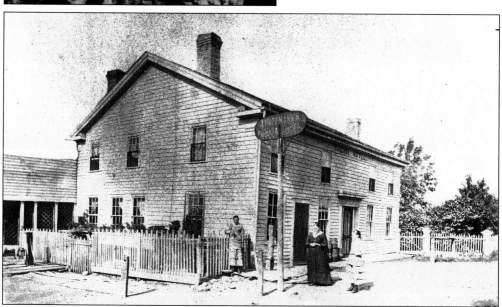

THE PHOENIX HOTEL, C. 1878. Elizabeth Hoffman became the sole proprietor of the Phoenix Hotel after the recent passing of her husband, John. From left to right are Eliza, Elizabeth (mother), and Ida Hoffman. Willis S. Spaulding of Oconomowoc wrote in his diary on Wednesday, January 1, 1879, "Started for Milwaukee. Stopped at Phoenix Hotel for dinner. Cost 41 cts. Toll gate Fair 7 cts. Splendid sleeping. Band plaid on street until 12 o'clock last night." (Courtesy of John Schoenknecht.)

THE WEDDING DAY, 1887. Mary Katharina Woelfel married Mathias Gebhardt at the Visitation of the Blessed Virgin Mary Catholic Church in Elm Grove on November 8, 1887. The couple raised eight children on their Brookfield farm (section 20) where he farmed and ran a successful threshing business. (Courtesy of Roger and Marion Woelfel.)

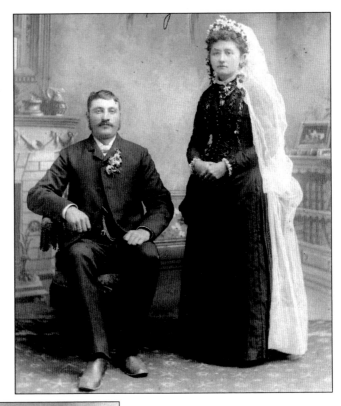

COUSINS, 1889. Posing from left to right are cousins Kunigunda, Conrad, and Annie Ramstack. Kunigunda and Annie were the children of George and Anna (Brendel) Ramstack, who ran a Brookfield farm (section 23). Conrad was the son of Frank and Anna Maria (Gebhardt) Ramstack, who ran a hotel and saloon at Elm Grove. The name Kunigunda has its roots in the region that is now part of the Czech Republic. Her's was a very common name for Bavarian girls during the 19th century. (Author's collection.)

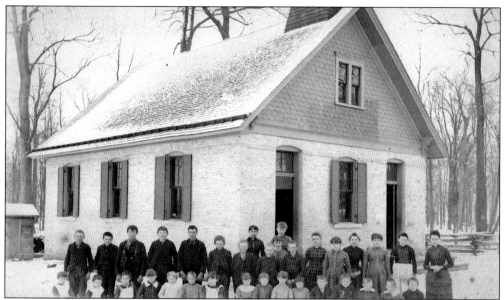

WOODSIDE SCHOOL, 1883. In 1973, Aenone Rosario wrote about her recollections of the old Woodside School in Brookfield (section 1) during the 1930s: "An old fashioned, pot belly stove stood in the corner of the cloakroom and was the only source of heat in the building. Drinking water came from a well in the yard, operated by a hand pump. And each morning the old bell under the steeple pealed out an invitation to a new school day." (Courtesy of Elmbrook Historical Society.)

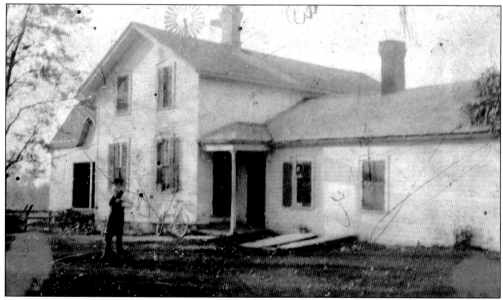

THE CHESTER A. BLODGETT FARM, C. 1898. Seen posing at his front door, Chester Blodgett, age 81, owned a Brookfield farm (section 29). His wife, Caroline, had died, and his six adult children resided at home. On March 26, 1903, the Waukesha Freeman reported, "A party of nine went to the home of C. A. Blodgett where the big baskets of luncheon were taken and a sugaring off was enjoyed. A jollier party has not often enjoyed the hospitality of the Blodgett home, which is noted for its good cheer." (Courtesy of Isabel Wray.)

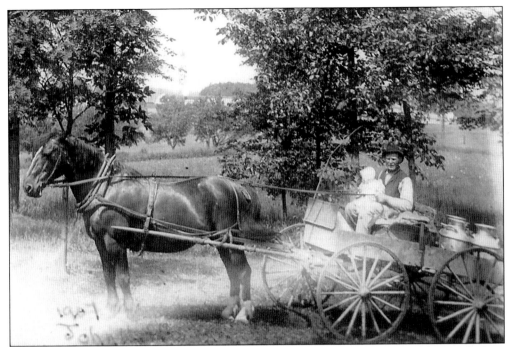

JOHN HOFFMAN, 1907. Holding baby Roy on his lap, John Hoffman delivered fresh milk from his (section 16) dairy farm to the train station at Brookfield, where it was sent off to fill the thirsts of Milwaukee's youth. (Courtesy of Sally Clarin.)

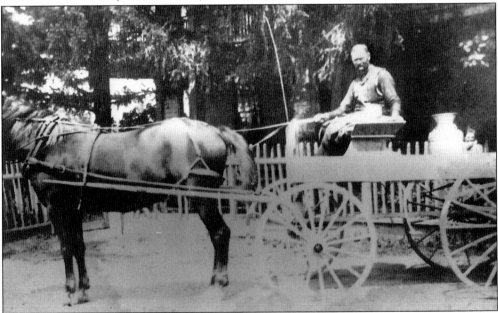

JOSEPH DECHANT, C. 1900. Stopping in front of the Half Way House where a transfer will take his milk into the city is Joseph Dechant. The *Waukesha Freeman* reported on March 26, 1903, "The old Watertown plank road has been in poor condition and Joe Dechant has been out with the scrapper to make repairs. Splinters Bros.' milk wagon stops now at Elm Grove instead of going to the 'Half-Way House' as the roads are so poor." (Courtesy of Craig Black.)

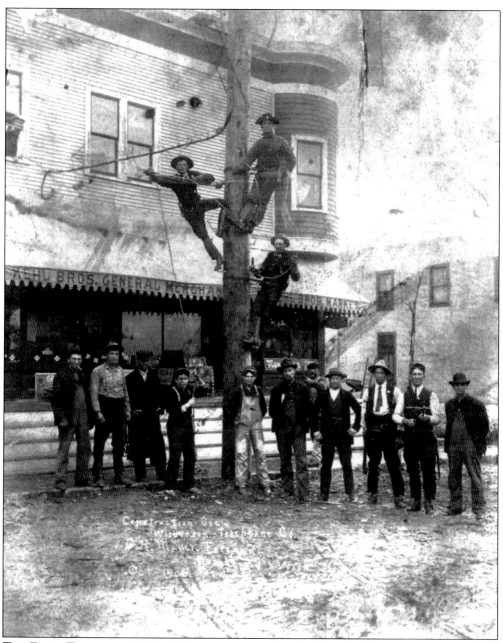

THE FIRST TELEPHONE, 1906. Pole men are running the first telephone lines into an office above Kehl Brothers General Store in the village of Brookfield (section 17). The man at the far right is Fred Celley. The man in the background, smoking a pipe, is Ernest Hahn. The description on the photograph reads, "Construction Crew, Wisconsin, Telephone Co., G. H. Many, Foreman, Brookfield, Wis., Oct., 1906." (Courtesy of Craig Black.)

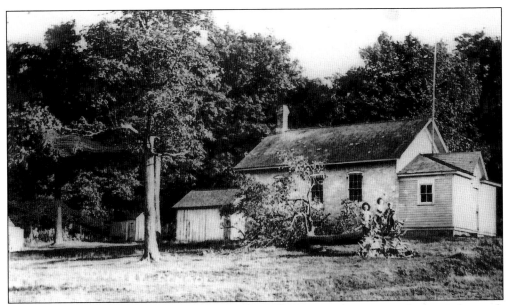

THE GREGG SCHOOL, C. 1890. Three young boys play on top of an uprooted tree on the north side of the Gregg School near Elm Grove. In 1905, Kate Gregg Warren provided her recollections of the school from the decade of the 1860s, "The ceiling on the boys side was covered with spit balls, and needless to say the desks were hand carved. This was an uninteresting place for a little girl to sit all day, on a seat so high that her toes could not touch the floor and only recite four times in the whole day." (Courtesy of Arline Kirkham.)

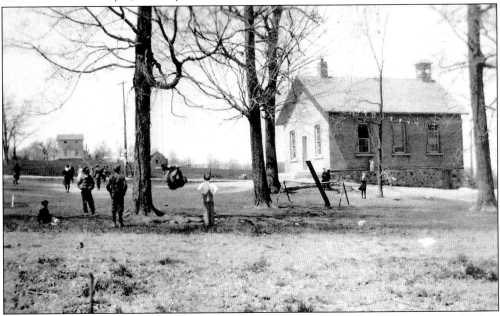

THE PUTNEY SCHOOL, C. 1900. Here children play on the grounds of the Putney School in Brookfield (section 16). On January 12, 1905, the *Waukesha Freeman* reported on the progress of the Putney School students: "The following students missed the least number of words in spelling: Geo. Lindquist, 0; Mike Stubinsky, 0; Gail Eichsteadt, 0; Harold Hoffman, 1: Marjorie Claflin, 1; and Charlotte Lindquist, 2.—Ethel M. Bennett, teacher." (Courtesy of Craig Black.)

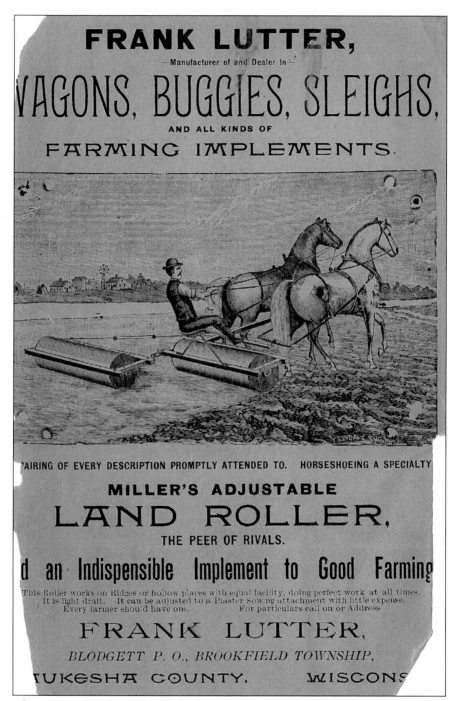

FRANK LUTTER, 1890. In 1882, Frank Lutter was a 39-year-old blacksmith from Germany. He owned a Brookfield (section 30) parcel. He and his wife, Christina, had three children, Mattie, Herman, and Oscar. Charles Freba, a wagon maker, and Henry Foss, a blacksmith, lived in this household and worked in Lutter's shop, according to the 1890–1891 *Waukesha County Gazetteer and Farmer's and Land Owner's Directory*. (Courtesy of Waukesha County Historical Society and Museum.)

THE SCHEIBE HOME, C. 1910. Posing from left to right behind a fence that was battered by snow and wind are Edward, Herman (father), Amelia, Edward, unidentified, Clara, and Anna (mother). In 1967, a Scheibe descendent wrote, "Five generations have worn the steps of the double stairway in its house. Reminders of the past are Grandpa Gustav's tiny-lensed reading glasses. Wilhelmina's handmade rocking chair sets on the porch and her wooden wardrobes are still in use." (Courtesy of Mary Scheibe.)

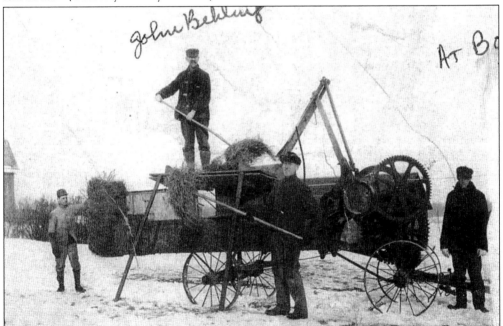

FEEDING STOCK IN WINTER, C. 1915. On a cold winter's day, Kilian Nettesheim brought his hay bailer over to the August Bolter farm (section 21) to help lay hay for feed. From left to right are an unidentified man, John Behling (standing on top), Kilian Nettesheim (standing in front), and Howard Spencer (at the far right). (Courtesy of Patricia Basting.)

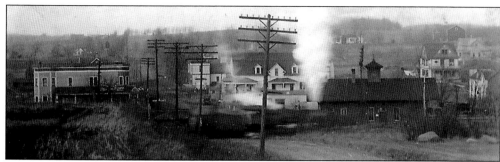

DANGEROUS WORK, C. 1911. Several Brookfield men were either severely injured or killed while working for the railroad at the dawn of the 20th century. On April 5, 1900, the *Waukesha Freeman* reported, "Tom Mitchell, of Elm Grove, had a close call Monday at Brookfield Heights, while cleaning the ash pan under one of the big engines on the Milwaukee road. The engineer let off steam of 150 pounds pressure, which stuck him above the right eye, also scalding his shoulder and back." (Courtesy of Craig Black.)

ST. DOMINIC'S CATHOLIC CHURCH, 1972. The oldest European ethnic settlement in Brookfield was Irish Catholic and dated to 1837 with the arrival of large numbers of Irish immigrants into the northern sections of the town. In 1843, the congregation built a small log structure consecrated to St. Dominic (section 6). The first resident pastor was Father Quinn. The congregation replaced the log structure with this stone building in 1866. (Courtesy of Arline Kirkham.)

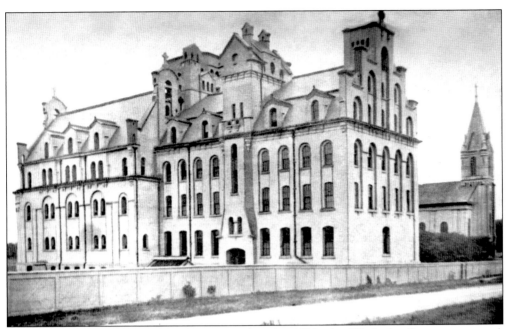

NOTRE DAME HALL, C. 1900. On December 21, 1899, the *Waukesha Freeman* reported, "The $100,000 building erected at Elm Grove by the Sisters of Notre Dame is completed and occupied. It is one of the largest and finest buildings in the county." (Courtesy of School Sisters of Notre Dame.)

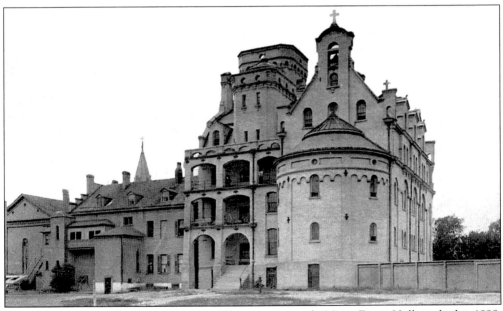

REAR VIEW OF NEW ADDITION, C. 1915. The cornerstone for Notre Dame Hall was laid in 1898. The large Bavarian-style structure served as a home of rest and an infirmary for the sisters. The church at the far left is the Catholic church, constructed in 1868. In the center is the original convent and school building, constructed in 1859. (Courtesy of School Sisters of Notre Dame.)

WILLIAM RILEY BLODGETT, C. 1878. William Riley Blodgett (1821–1911), a native of Ontario County, New York, purchased a Brookfield farm (section 20) in 1842. In 1872, Blodgett was victimized by two horse thieves. The *Waukesha Freeman* of September 30, 1872, reported, "Two men were arrested at Waukesha on Monday on the charge of stealing a horse from Mr. W. R. Blodgett of Brookfield and after examination before Justice Hawkins were committed in default of $1000 bail." (Courtesy of Waukesha County Historical Society and Museum.)

ZELPHIA (WADSWORTH) BLODGETT, C. 1878. The second wife of William Riley Blodgett, Zelphia (Wadsworth) Blodgett (1824–1911) came west with her husband during the 1840s. The couple had one child—William. By the 1870s, John Smith, a blacksmith, and Ryson Louis, the baggage master at Brookfield station, were also residing in the Blodgett household. (Courtesy of Waukesha County Historical Society and Museum.)

A UNIQUE SMOKEHOUSE, 1974. Possibly as early as the 1890s, Henry Reinders designed and built this unique circular smokehouse on his Brookfield farm (sections 27 and 28) "so the smoke would not hide in the corners," some old-timers have suggested. The smokehouse has been restored and is now preserved on the grounds of the Elmbrook Historical Society's Dousman Stagecoach Inn Museum. (Courtesy of Arline Kirkham.)

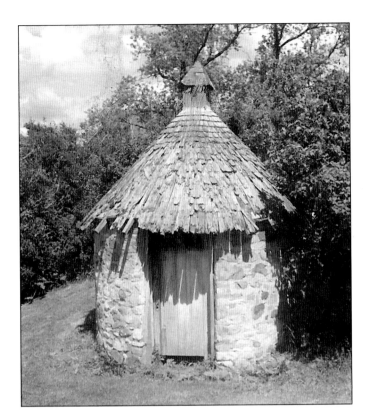

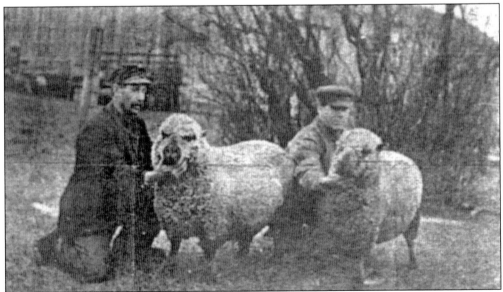

SHROPSHIRE SHEEP, C. 1908. From left to right are Albert Hahn and Charles Hill of Brookfield, members of the Wisconsin Sheep Breeds Association, who showed sheep at the Wisconsin State Fair for several years during the early 1900s. The *Waukesha Freeman* of November 1, 1922, reported, "With a live committee of George Beidenbender, George Blodgett and Albert Hahn, it looks as though the November meeting of the Brookfield Farm Bureau will be especially interesting." (Courtesy of Arline Kirkham.)

CHRISTINA DUNKEL, C. 1898. In 1887, Charles and Barbara (Gredler) Dunkel took over operation of a Brookfield farm (section 27) previously owned by Charles Zimdars. Christina Dunkel (1813–1899), shown here, the mother of Charles Dunkel, resided with the family. The farm eventually grew to 222 acres and included the home that is known today as the old Dousman Inn, preserved by the Elmbrook Historical Society. (Courtesy of Elmbrook Historical Society.)

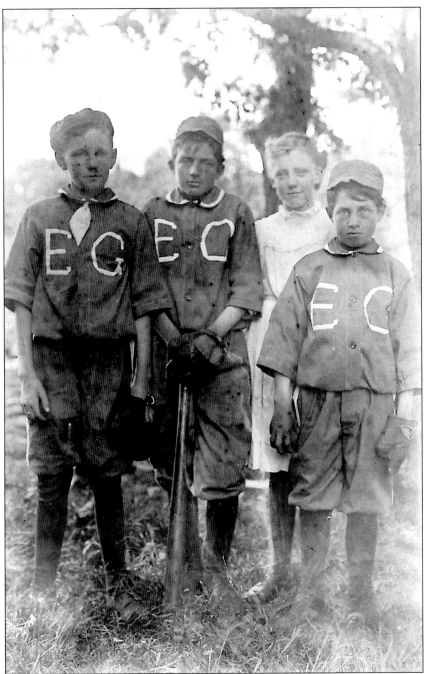

BASEBALL, C. 1898. Three members of a boys' Elm Grove baseball team and a young lady pose for this image taken about the dawn of the 20th century. The second half of the 19th century was the era when baseball should have been referred to as "America's game." Nearly every small and large town in Wisconsin sponsored teams. The *Waukesha Freeman* of June 28, 1877, reported, "This town has baseball, fever bad. It can now boast of no less than four clubs, either one of which will, in a short time, be prepared to play for the championship of the United States or that of Brookfield. It matters but little which." (Courtesy of Craig Black.)

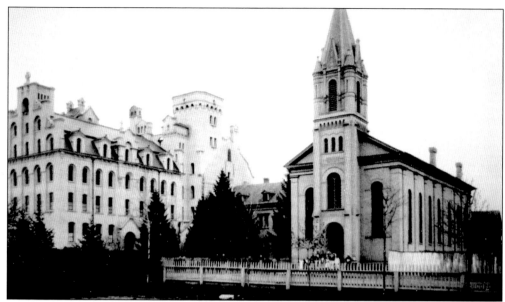

SCHOOL SISTERS OF NOTRE DAME GROUNDS, C. 1905. Seen here from left to right are Notre Dame Hall, constructed in 1899; the original Our Lady of Visitation Convent, constructed in 1859; and of the Visitation of the Blessed Virgin Mary Church, built in 1868. A Sunday school class of 12 children stands on the church steps along with two sisters. In addition, about 13 adults can be seen standing along the fence line, including a priest. (Courtesy of School Sisters of Notre Dame.)

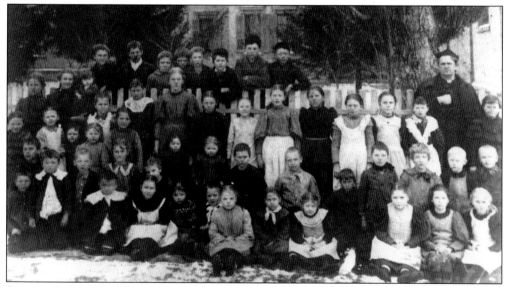

SCHOOL SISTERS OF NOTRE DAME PAROCHIAL SCHOOL, C. 1903. In the first row wearing a big white collar is Mary Reinders. In the second row, the fourth student from the right is John Ramstack, and at the far right is Clara Reinders. In the third row, the fourth girl to the right of the tall girl is Kate Libby. The priest is Reverend Haberstock. Standing behind the fence from left to right are the priest's housekeeper, her nephew, and her niece. The other five in that row are George Woelfel, Matt Wamser, John Simon, Herman Marks, and Ed Jewert. (Courtesy of Doris Haley.)

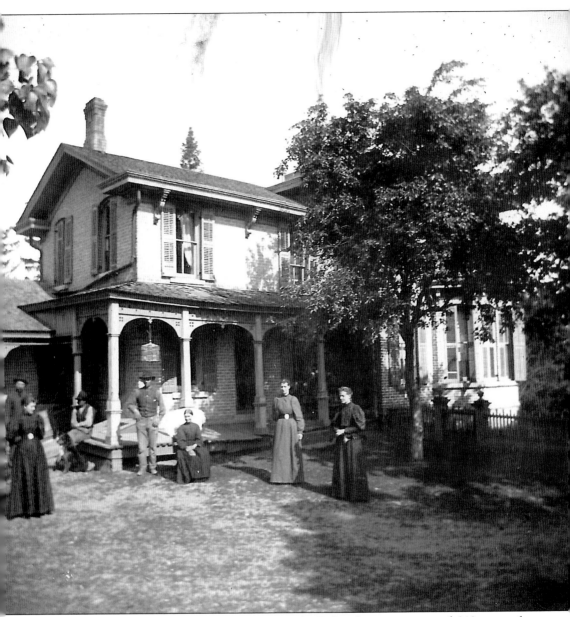

THE AUGUST BOLTER HOME, C. 1900. By 1900, the Bolter farm encompassed 240 acres of quality farmland in Brookfield (sections 20 and 21). This view from the front of the house shows, from left to right, John Spencer, Matilda Spencer, Charles Bolter (sitting on the porch), August Bolter, Minnie Bolter, Alice Bolter, and Mamie Bolter. The *Waukesha Freeman* reported on December 3, 1903, "August Bolter was severely injured by a fall from a load of shocked corn to the frozen ground; his injuries were attended to by Dr. Partridge of Pewaukee and a gash on his head required eleven stitches." (Courtesy of Evelyn J. Nicholson.)

BLODGETT'S HALL, 1901. Horace Blodgett (left) built a potato warehouse along the tracks at Brookfield Junction (section 16), which met with great success during the decade of the 1900s. He provided a hall for community entertainment on the second floor. (Courtesy of Arline Kirkham.)

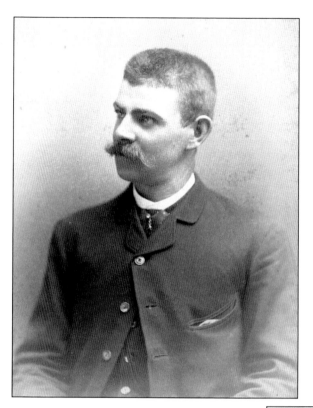

ENTERTAINMENT, 1923. The *Waukesha Freeman* reported on January 22, 1903, "An entertainment will be given at Blodgett's hall on Tuesday evening, Jan. 27, under the auspices of Ernest Benecke. An able elocutionist and also talented pianist of Milwaukee have been engaged for the occasion." (Courtesy of Isabel Wray.)

TOLLGATE HOUSE, C. 1925. The tollgate keeper's home was built up close to the road to enable him to be on hand to collect tolls from travelers using Watertown Plank Road. William Soloman, who collected tolls for the Plank Road Company with his son Jacob and William's mother, Maria, lived here from 1867 to 1892. The house was located along the north side of today's Bluemound Road (section 26). On November 27, 1902, the *Waukesha Freeman* reported, "Florian Norwak has built a new cellar and moved the toll gate house, one of the town's old landmarks, over it. He did all the work himself. It is now nearer the woods, where he can keep warm in spite of the price of coal." (Courtesy of Arline Kirkham.)

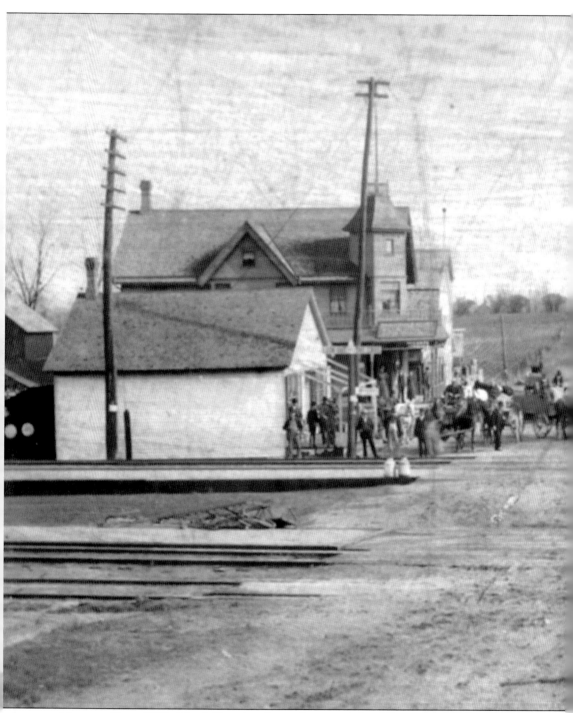

MARKET DAY, 1902. The *Milwaukee Sentinel* reported the following regarding the village of Brookfield on May 25, 1902: "The big day of the week is Friday, when the farmers do their marketing. On that day as many as eighty vehicles of all sorts may be seen grouped about the depot and post office, the latter of which consists of a case containing about 100 pigeon holes for the reception of mail. On this day old acquaintances are renewed, but is a rare occasion when

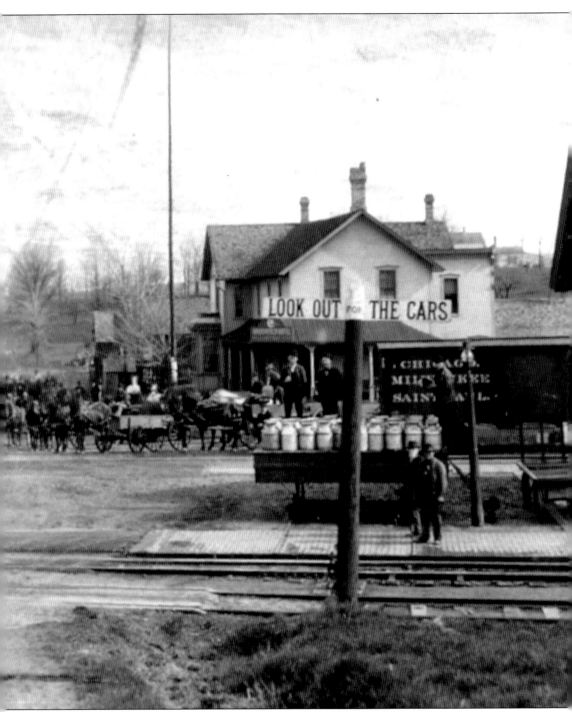

a new one is formed, for the reason that the dwellers of Brookfield Township never leave their confines. Dairy products, potatoes, grains, and live stock are brought in, and feed, dry goods and other necessities taken out. On that day also the farmers may be seen smoking cigars in true metropolitan style." (Courtesy of Elmbrook Historical Society.)

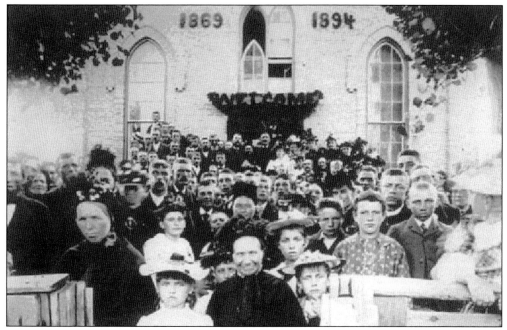

A 25TH ANNIVERSARY, 1894. In 1926, Cordelia Klug reported that Trinity Evangelical Church (section 4) was shingled, the old organ was raffled, and $30 was allowed to purchase a new organ in 1891. In this image the congregation gathers to celebrate the 25th anniversary of the church in 1894. (Courtesy of Bob Rohrig and Rich Wullschleger of Trinity United Church of Christ in Brookfield.)

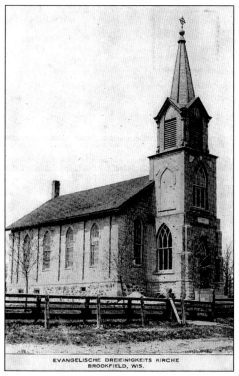

TRINITY EVANGELICAL CHURCH, C. 1904. In 1926, Cordelia Klug went on to note, "In 1904, the Trinity congregation of Brookfield [section 4] decided to build a new steeple on the church. There had been a steeple on the church when it was first constructed, but it was merely temporary, as it was very small." (Courtesy of Craig Black.)

Three
A GREAT CONFLAGRATION

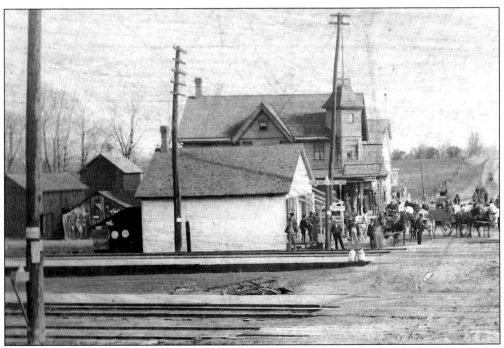

BROOKFIELD SUFFERS TERRIBLE LOSS BY FIRE, 1905. Brookfield Junction was scourged by fire on the morning of January 23, 1905. Each building in this image was consumed. The *Waukesha Freeman* reported on January 26, 1905, "The fire started at Kiehl's meat market about nine o'clock Monday morning. An overheated stove was the cause. The fire burned fiercely and the villagers worked heroically to put it out." Only the Eichstedt hotel and the Chicago, Milwaukee, and St. Paul depot were left standing. (Courtesy of Elmbrook Historical Society.)

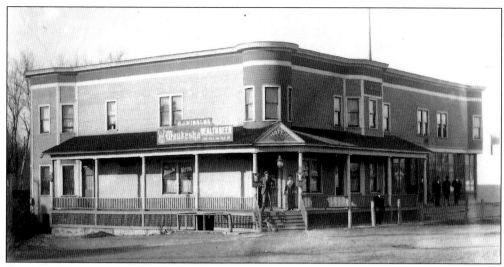

ORWIN WIBALDA'S HOTEL AND SALOON, C. 1909. The *Waukesha Freeman* reported on February 2, 1905, "Former Sheriff Wm. A. Scholl is preparing to erect a fine large business block in Brookfield, to take the place of the buildings burned last week. The building will include a hotel, a general store, a hardware store, a meat market, physicians' and dentists' offices, and on the second floor flats for residence." A new tenant, O. J. Wibalda, advertises, "Waukesha Health Beer and Old Ale." (Courtesy of Arline Kirkham.)

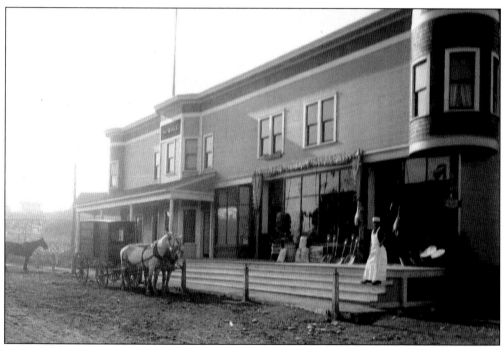

KEHL BROTHERS MEAT MARKET AND GENERAL MERCHANDISE, C. 1906. Andrew Kehl, a butcher, is seen here wearing an apron and standing at the far right. He and his brother Peter (not shown) opened their new store in the large commercial building put up by William Scholls following the 1905 fire. The wagon hitched at the front of the store is their meat delivery wagon, built by Peter Becker, the local blacksmith. (Courtesy of Elmbrook Historical Society.)

BROOKFIELD POST OFFICE, C. 1915. A "coupala fellers" are standing in front of the Kehls' general store at Brookfield Junction, which also served as the post office. The small sign in the window promotes the purchase of "Christmas Seals." (Courtesy of Arline Kirkham.)

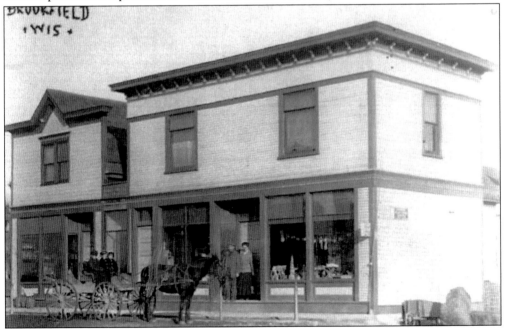

LOUIS KELLER GENERAL STORE, C. 1909. Louis and Olivia Keller are standing in the doorway of their renovated general store at Brookfield Junction. The *Waukesha Freeman* reported on December 31, 1914, "Louis Keller is making great improvements in his buildings and will soon have the largest store in town." (Courtesy of Arline Kirkham.)

GEORGE WOELFEL, C. 1900. George Woelfel, born at Rollhofen, Bavaria, in 1828, immigrated to Brookfield (section 23) in 1845. On January 30, 1902, the *Waukesha Freeman* printed the following: "There is nothing more important than good roads to the material welfare of the country, and George Woelfel's idea is to hitch a big traction engine ahead of one of our road scrapers next spring when the ground is soft and turnpike our turnpike road." (Courtesy of Roger and Marion Woelfel.)

REGINA HABERMAN, C. 1900. Woelfel's wife, Regina (1835–1907), was also born in Bavaria. She married Woelfel at St. Ambrose Catholic Church on July 8, 1852. The church, at the time, was a log structure, built along the east side of today's Highland Drive (section 23). As late as 1902, eight adult Woelfel children—Frank, Catherine, Simon, Regina, Cunnie, Leana, and Maggie—continued to reside in the family household. (Courtesy of Roger and Marion Woelfel.)

AGNES BLEIMEISTER, C. 1901. At age six in 1901, Agnes Bleimeister attended Pleasant Hill School at Blodgett. Her parents, Henry and Rosa Bleimeister, ran a Brookfield farm (section 34). (Courtesy of John Schoenknecht.)

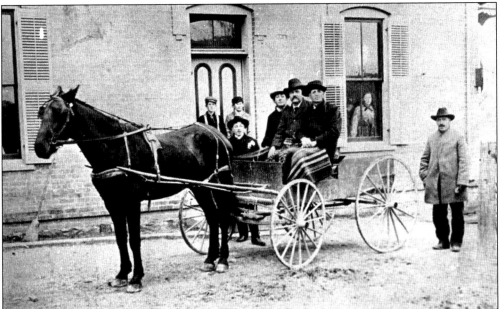

GOERKE'S CORNERS, C. 1900. This image was taken at the side of the Junction House (section 30), owned by Fred Goerke, whose family is pictured. From left to right are Fritz and Eddie (standing at the door), Grover (standing next to the wagon), Amanda, Fred (father), John (seated in the wagon), and Mata Goerke (peering out the window). An unidentified man stands behind the wagon. (Courtesy of Waukesha County Historical Society and Museum.)

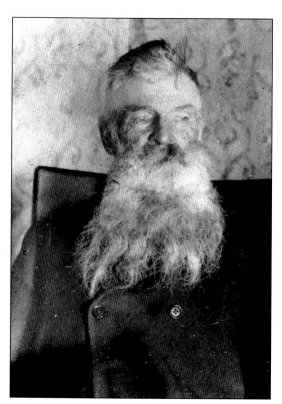

CHESTER A. BLODGETT, C. 1903. Chester A. Blodgett was a retired farmer from Buffalo, New York, who owned a Brookfield farm (section 29). His wife's name was Caroline. They had six children—Horace, Mami, Nellie, George, Bessie, and Mabel. Roy Aitken recalled in 1968, "My sister Jessie often spoke of trading lunches with her good friend Nellie Blodgett. She was always willing to do that because Nellie's mother made such wonderful cake." (Courtesy of Isabel Wray.)

CAROLINE (FRITZ) BLODGETT, c. 1903. When this image was taken in 1903, Caroline was 54 years old, while her husband, Chester, who had been married twice previously, was 86. The Blodgetts ran an 80-acre farm. A fact of life during the 19th century was that men outlived women, mainly due to a high mortality rate associated with childbearing and an excessively heavy workload often placed on women. (Courtesy of Isabel Wray.)

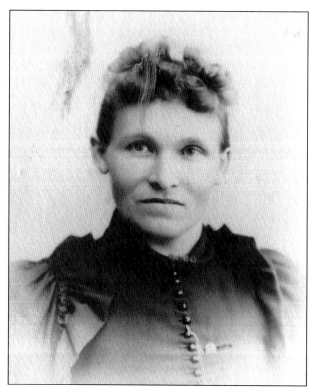

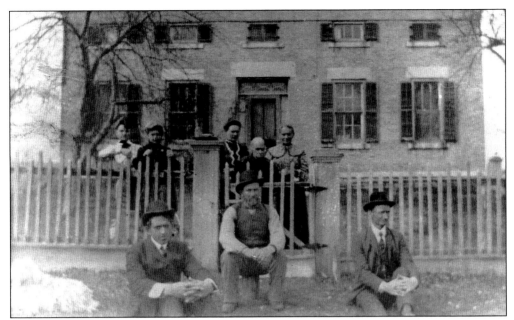

JOHN GRAMINS HOMESTEAD, C. 1903. Sitting in front of the fence on the John Gramins farm (section 32) from left to right are (first row) Henry Gramins (son), John Gramins (father), and George W. Hall; (second row) Gussie Gramins (sister), Flossie Hall, Mrs. George W. Hall, Obbie (Genke) Fenner (mother of Wilhelmina), and Wilhelmina Gramins (mother). (Courtesy of Waukesha County Historical Society and Museum.)

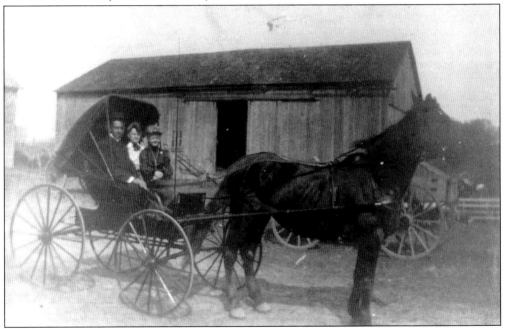

GRAMIN'S FARM, C. 1903. With their threshing barn in the background, posing in a buggy on Davidson Road in Brookfield (section 32), from left to right, are Henry Gramins (brother), Gussie Gramins (sister), and Flossie Hall. (Courtesy of Waukesha County Historical Society and Museum.)

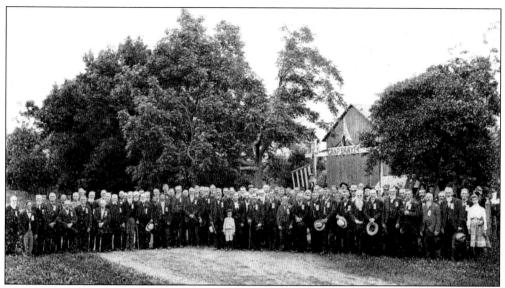

REUNION OF THE 28TH WISCONSIN REGIMENT, JUNE 30, 1903. Veterans of the 28th Wisconsin Regiment pose while participating in a reunion held on the farm of Lauren Barker in Brookfield (section 17). The *Waukesha Freeman* reported on July 2, 1903, "Camp Barker lacked nothing in preparation, even the tents were there, and the guard wearing the old army cap and overcoat of blue, and bearing the same musket that Mr. Barker carried for three years during the sixties, stood at the entrance to the camp to remind one of days gone by." (Courtesy of Historic Photograph Collection/Milwaukee Public Library.)

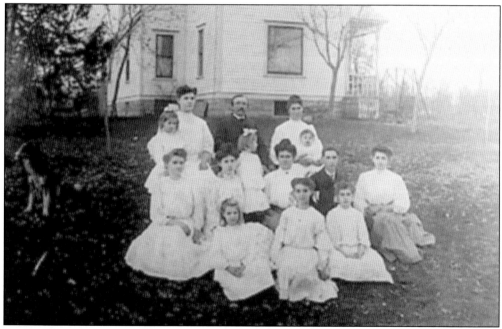

EMERY EBLE FAMILY, C. 1903. Roy and Julia Eble must have had a their hands full raising 12 children on their Brookfield farm (section 29). Pictured from left to right are (first row) Elsie, Grace, and Della; (second row) Katherine, Ida, Florence, Amanda, George, and Cora; (third row) Julie, Mollie, Roy (father), Julie (mother), and Roy (on Julie's lap). (Courtesy of Elaine Moss.)

CHARLES DUNKEL, C. 1906. In 1887, Charles Dunkel (1843–1909) and his two sons, Henry and Herman, moved to Brookfield from Wauwatosa and in the same year purchased a 180-acre farm (section 26) from Charles Zimdars. The farmhouse, already standing on the property, is the same building most local residents today identify as the old Dousman Inn. (Courtesy of Elmbrook Historical Society.)

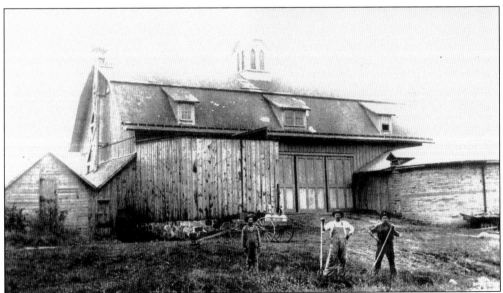

CHARLES DUNKEL BARN, C. 1890. The barn was located along the south side of Watertown Plank Road across from the Dunkel house. Posing in front of the barn from left to right are Henry Dunkel, Charles Dunkel (father), and Herman Dunkel. A wagon holding milk cans stands in front of the barn. The image of the barn is very unique, revealing, among other features, an early circular silo that was built low to the ground, a style not often seen in historic Wisconsin barns. (Courtesy of Craig Black.)

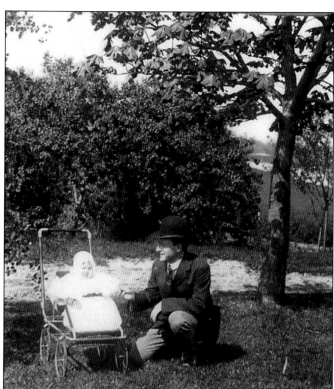

ARTHUR HOFFMAN, 1907. Arthur Hoffman enjoys time spent with his baby brother Roy at the home of their parents, John and Harriet Hoffman. The Hoffmans encouraged their children to read and pursue education. The *Waukesha Freeman* of February 9, 1899, recorded, "Several members of the History Club met at the home of Mr. and Mrs. John Hoffman on Robert Burns' birthday anniversary to praise his memory." (Courtesy of Sally Clarin.)

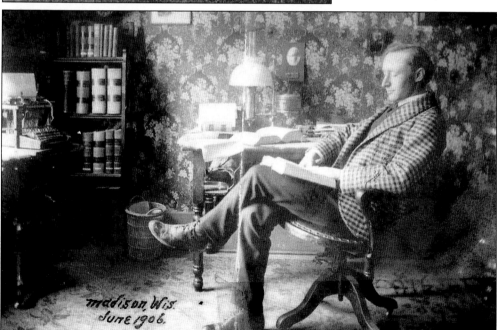

ALBERT HOFFMAN, JUNE 1906. Albert, a son of John and Harriet Hoffman, studies in his dorm room at the University of Wisconsin in Madison. Although several young people from Brookfield did go off to college at the dawn of the 20th century, a college education was not the norm for most of Brookfield's young adults during this period. (Courtesy of Sally Clarin.)

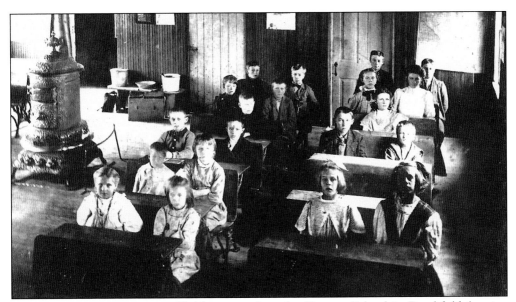

COTTAGE SCHOOL, C. 1906. Children attending the Cottage School in Brookfield (section 27) are shown here. From left to right are (first row) Hilda Reinders, Frieda Wallman, and two unidentified; (second row) two unidentified; (third row) Walter Hoffman, Albert Sheets, and two unidentified; (fourth row) unidentified and Margaret Behling; (fifth row) Harold Behling, unidentified, Mary Hoffman, and unidentified; (sixth row) unidentified, Robert Behling Jr., Alvin Mierow, and Henry Mierow. (Courtesy of Craig Black.)

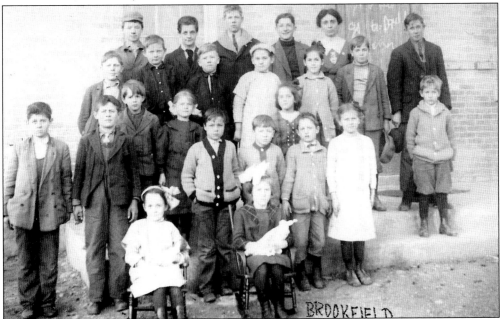

THE PUTNEY SCHOOL, 1912–1913. This image shows the Putney School located just to the north of the village of Brookfield Junction (section 16). In the third row, the fifth student from the left is Katherine Kiehl. Wearing a white dress and sitting in the front is Genevieve Turner. Standing in the fifth row in front of the school door is Franklin Wirth. In November 1954, Wirth was elected the city of Brookfield's first mayor. (Courtesy of Larae Svehlek.)

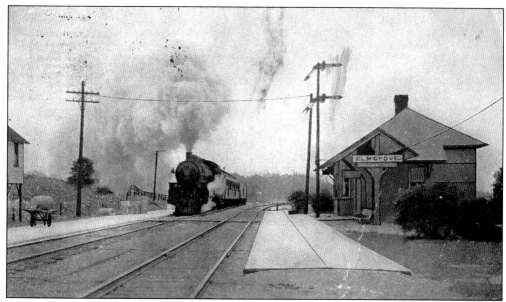

SPEEDING LOCOMOTIVES, C. 1911. At the dawn of the 20th century, railroad accidents involving fatalities were not uncommon at the Elm Grove train crossing. On December 13, 1906, the *Waukesha Freeman* reported, "Two of our most worthy husbandmen, while riding west on the Watertown road Friday morning, were struck by the fast mail train. Their death was instantaneous. Mr. Bullis was carried a mile on the pilot before the train could be stopped. Mr. Smith's body was thrown high on the banks of Frank Ramstack's woods." (Author's collection.)

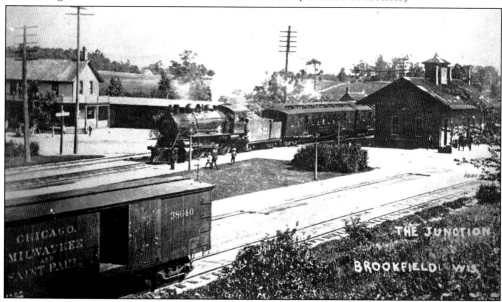

MANY TRAINS PASS THROUGH BROOKFIELD, C. 1905. The *Milwaukee Journal* on May 27, 1902, reported, "Nearly 100 eight-gallon cans of milk are shipped from Brookfield Junction to Milwaukee daily at about 90 cents per can. The railroad company takes in about $300 dollars a week in passenger and freight transportation. Between Brookfield Junction and Milwaukee is a double track, and another from LaCrosse to Milwaukee, passing through Brookfield, is in process of construction." (Courtesy of Arline Kirkham.)

Four

THE TORNADO OF AUGUST 16, 1907

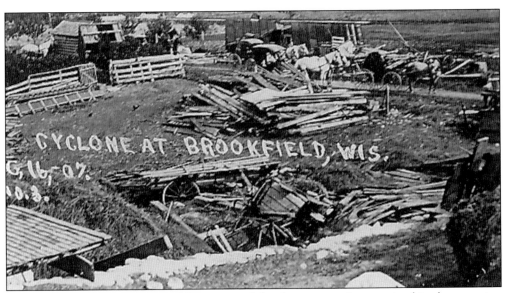

IMMENSE DESTRUCTION, 1907. The extent of the damage can be seen in this close-up view of the buildings on the George Dolph farm in Brookfield (section 17). The *Waukesha Freeman* on August 22, 1907, reported, "The first storm of really cyclonic character which has visited this county in many years came just at midnight Thursday, and did an enormous amount of damage, reaching initially into the hundreds of thousands of dollars . . . The railway water tank at Brookfield was strained and bent so by the force of the wind that the iron bands surrounding it broke." (Courtesy of Craig Black.)

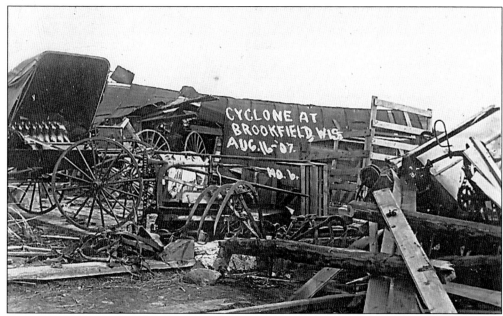

ASTONISHING DAMAGE, AUGUST 16, 1907. The *Waukesha Freeman* went on to report, "Mr. William J. Clasen's place was swept clean of all buildings. The destruction, the tangle of boards and beams and rafters and farm machinery and dead horses and cows and hay and grain piled and tangled together made a scene of desolation which must be scene to be appreciated." (Courtesy of Craig Black.)

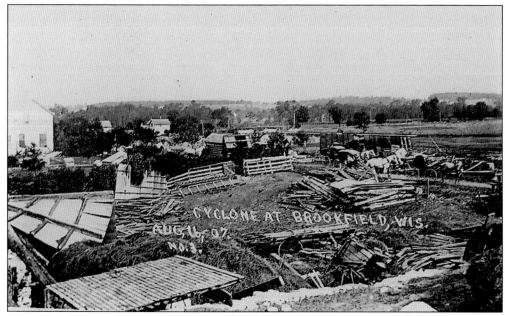

BARN DESTROYED, AUGUST 16, 1907. The newspaper account also reported, "At George Dolph's farm, a large hay barn was wrecked and another barn damaged. The windows on one side of the house were blown in." (Courtesy of Craig Black.)

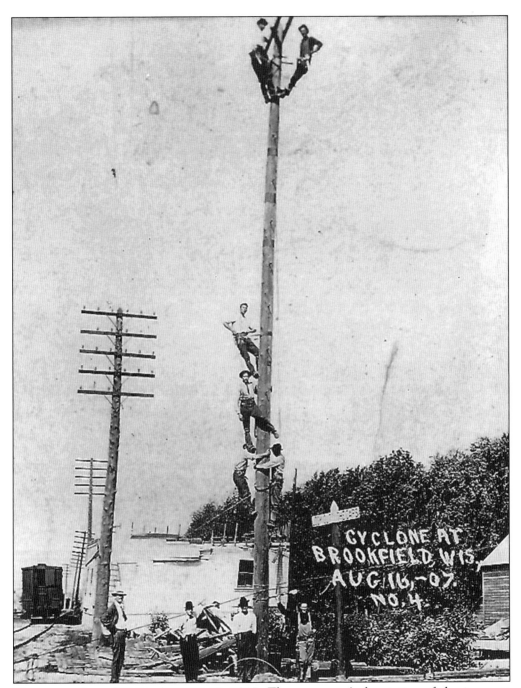

TELEPHONE LINE DOWN, AUGUST 17, 1907. The newspaper's description of the immense damage continued, "The woods on the farms of Mrs. C. Busse, L. Barker and T. H. Tucker, have, it is thought, about one fourth or more of their trees down. Many telephone poles were blown down and wires loosened. All the long distance lines were down and all except two or three of the local lines. The telephone company has a gang of men at work and will soon have all lines in order again." (Courtesy of Craig Black.)

CALM SUMMER'S DAY, C. 1911. These two young ladies are walking north on the pathway running alongside Brookfield Road down the hill into the tranquil village of Brookfield Junction. (Courtesy of Larae Svehlek.)

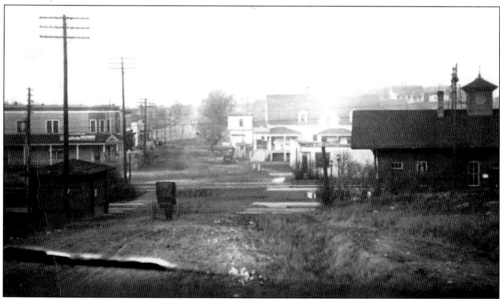

END OF THE HORSE AND BUGGY ERA, C. 1911. Ten years after this wonderful image of a lone buggy quietly ambling through the village of Brookfield Junction was taken, this sight appeared no more. By 1920, most Brookfield farmers had purchased their first automobile. In the beginning, Brookfield farmers hated them. On June 23, 1904, the *Waukesha Freeman* reported, "Automobiles are too numerous to be safe in these parts. You can not drive in any direction without seeing one." (Courtesy of Arline Kirkham.)

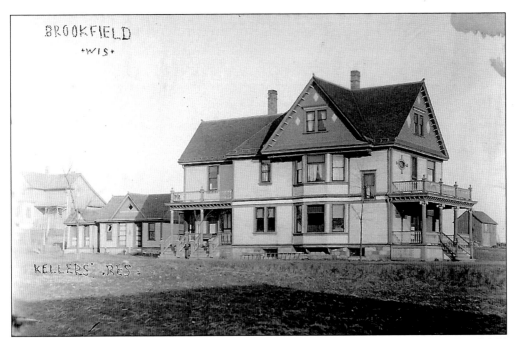

LOUIS KELLER RESIDENCE, C. 1909. Louis Keller, a farmer and general store owner at Brookfield Junction (section 16), apparently met with great financial success. On September 3, 1904, the *Waukesha Freeman* reported, "Brookfield Heights will soon assume a metropolitan appearance as Louis Keller's large new house is nearing completion." (Courtesy of Arline Kirkham.)

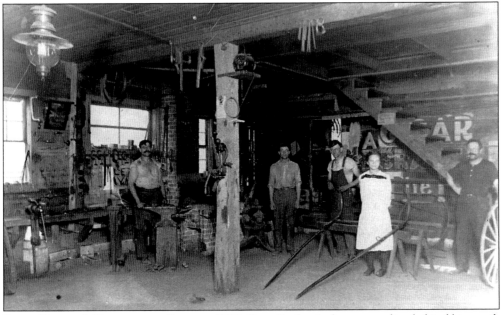

PETER BECKER'S BLACKSMITH SHOP, C. 1910. Peter Becker is shown standing behind his anvil, while his wife, Ida, and three wagon makers pose at right. The *Waukesha Freeman* reported on January 22, 1903, "Peter Becker has consolidated his wagon and blacksmith shop, which is a great improvement. He is now ready to put up a new farm wagon, carriage, sleigh, or hayrack." (Courtesy of Elmbrook Historical Society.)

TANNENWALD FARM, C. 1910. This is Brookfield Road running north from Bluemound Road at the Ernest Benecke farm. Benecke's crew of farmhands shows off his workhorses, wagons, sheep, and so on for the taking of this photograph. That may even be Benecke waving from the porch at the front of his house. (Courtesy of Arline Kirkham.)

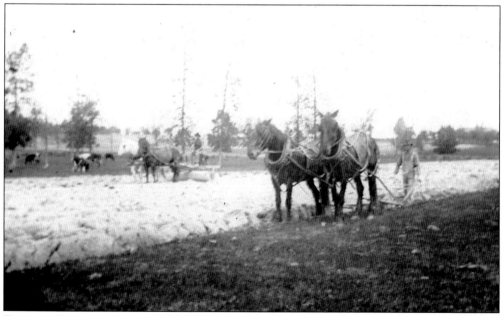

TURNING OVER THE SOIL, C. 1921. This image shows one man working behind a two-horse-drawn plow and another rolling over the furrows on the August Bolter farm (section 21). Benecke, a longtime Brookfield resident, wrote in 1901, "In no occupation do a man's daily labors bring him in such close companionship with the Great Creator as in the cultivation of soil." (Courtesy of Evelyn J. Nicholson.)

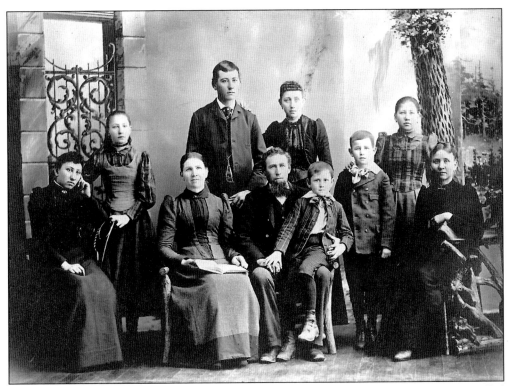

THE SCHEIBE FAMILY, C. 1890. Scheibe family members pose in front of what was once called the "mansion on North Avenue" for this family photograph. Pictured from left to right are unidentified, Clara, Anna (mother), Edward, Herman (father), Daniel (on Herman's lap), Dorothy, Edward, Amelia, and Minnie (grandmother). (Courtesy of Mary Scheibe.)

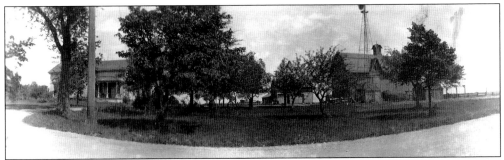

THE SCHEIBE FARM, C. 1900. Here is a very unusual panoramic view of a Wisconsin farm around 1900. Regarding the barn, Wisconsin architectural historian Richard Perrin wrote, "Stone masons managed to lay walls by fitting one stone carefully against another. From such mosaic treatment it was a short step to square the stones on all sides and lay them up as coursed ashlar. [Ashlar blocks are large rectangular blocks sculpted to have square edges and even faces.] One of the earliest attempts along these lines was the Scheibe barn." (Courtesy of Mary Scheibe.)

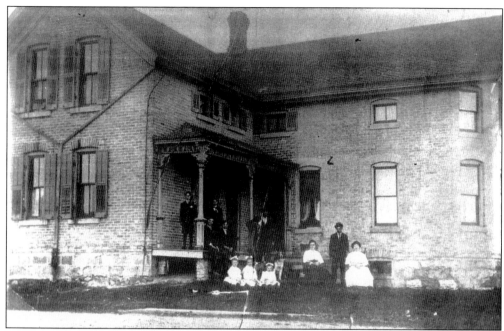

MATT GEBHARDT FAMILY, C. 1912. Gebhardt family members from left to right (standing on the porch) are Joseph, Aloysius, and Matthew Sr. (father); (sitting on the porch) Simon and Matthew Jr.; (sitting on the grass) Lorraine, Marie, and Cecilia; (sitting to the right) Mary (mother), and Regina; (standing to the right) Frank. Local lore has that every time the Gebhardts had another child, they added another addition onto the house. (Courtesy of Elmbrook Historical Society.)

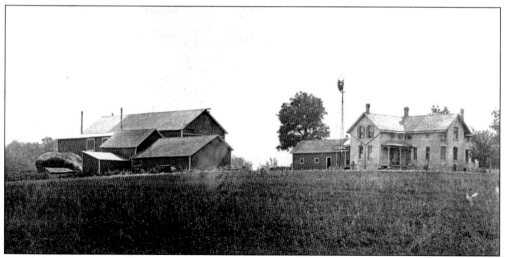

MATTHEW GEBHARDT FARM, C. 1912. Besides running a successful 120-acre farm (section 22), Matthew Gebhardt Sr. gained a county-wide reputation for his seasonal threshing business. An accident was reported by the *Waukesha Freeman* on September 6, 1900: "While Mat. Gebhard was crossing Popple Creek with his steam engine; the bridge broke, letting it into the water six or seven feet below. No one was seriously hurt, though the threshing hands narrowly escaped drowning." (Courtesy of Elmbrook Historical Society.)

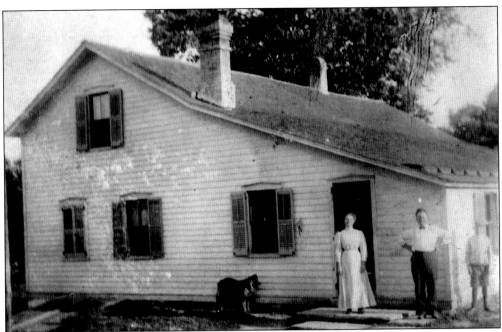

THE WOELFEL HOME, C. 1911. Shown here from left to right are Katie, Simon, and Frank Woelfel, who now run their parents' farm in Brookfield (section 23). The Woelfel house may date from the 1850s. It is characterized as a saltbox design, having a long, sloping roof running to the back of the house, which is typical in style to numerous Colonial New England homes, some dating from the 16th century. (Courtesy of Roger and Marion Woelfel.)

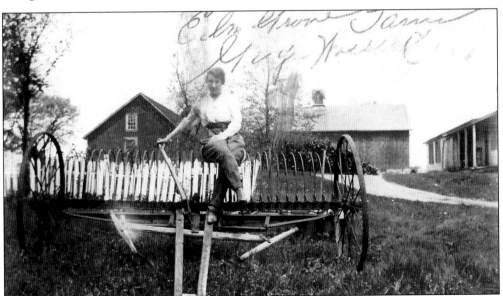

A HAY RAKE, C. 1911. Another Woelfel sister, Helen, poses on top of a hay rake parked on the family farm. Apparently Simon Woelfel met with great success, as the *Waukesha Freeman* reported on May 8, 1902, "A quartette of Brookfield statesmen drove about town with Simon Woelfel's big black team Sunday, smoking black cigars, which came direct from Cuba." (Courtesy of Roger and Marion Woelfel.)

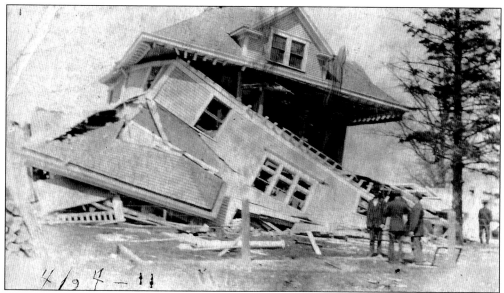

A GAS EXPLOSION, 1911. During the early years of the 20th century, several Brookfield residents began converting from kerosene to gas lighting. Although gaslights offered a welcome alternative to the dirt and odor of the kerosene lamps, as the image above reveals, gas lighting could be dangerous. Joseph Ramstack of Elm Grove wrote at the time, "This is the Vogel explosion which I wrote to you about the time it happened, about 2 miles from our place." (Author's collection.)

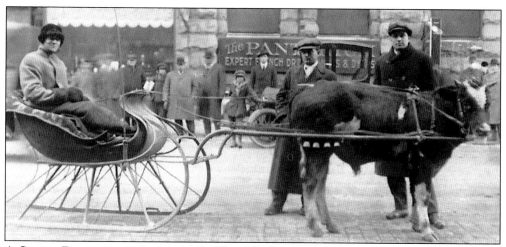

A SLEIGH DRAWN BY A STEER, 1912. This J. Robert Taylor photograph was taken at North Second Street and West Wisconsin Avenue for the *Milwaukee Journal* and shows Brookfield residents, from left to right, Joseph Gebhardt, Joseph Ramstack, and William Gebhardt. The caption reads, "This sleigh drawn by a steer was driven from Brookfield, Wis., in the winter of 1912." (Author's collection.)

Five

THE VILLAGE OF ELM GROVE

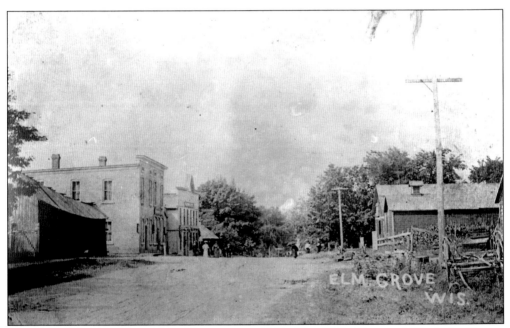

LOOKING WEST THROUGH THE VILLAGE, C. 1911. The 1880 *History of Waukesha County* reports, "The majority of the inhabitants of Elm Grove are German and it is an exceedingly quiet little burg." Looking west, at the image above, on the south side of the street are (from left to right) Frank Ramstack's horse stable, boardinghouse, and saloon and Theodore Reusch's hotel and saloon. Across the road is John Birner's wagon and blacksmith shop. In the distance, several village residents can be seen strolling up the road dressed in their Sunday best. (Courtesy of Doris Haley.)

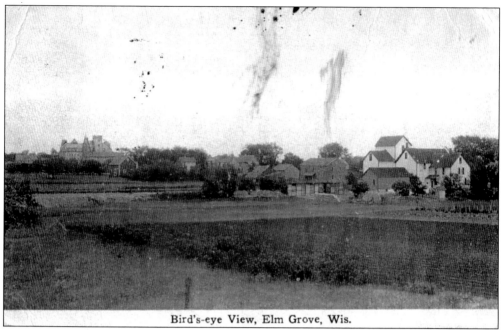

BIRD'S-EYE VIEW OF ELM GROVE, C. 1911. This image, looking southeast into the village, shows, from right to left, John Reinders's large, white store and gristmill; the tracks of the Milwaukee and St. Paul Railroad; William Hinze's boardinghouse, saloon, and blacksmith shop; Theodore Reusch's home, saloon, and hotel; the John Sanders home; the horse barn of the School Sisters of Notre Dame; the Catholic church; the Notre Dame convent; and, across the road, the priest's rectory. (Author's collection.)

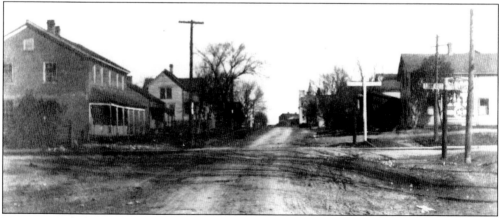

WATERTOWN PLANK ROAD AT ELM GROVE, C. 1910. Despite the obvious lack of maintenance, the privately owned plank road company continued to collect tolls for public use of this highway until 1901. On the north side of the street from left to right are the buildings of William Hinze and the Woelfel home. On the south side of the road is Old Soldier's Home, a boardinghouse and saloon run by George Ramstack, a Civil War veteran. The star surrounded by a crescent moon image, as it appears on his building, was the symbol used to identify Civil War veterans of the 28th Wisconsin Volunteer Regiment. In the far distance is the barn of Albert Schrubbe. (Courtesy of Doris Haley.)

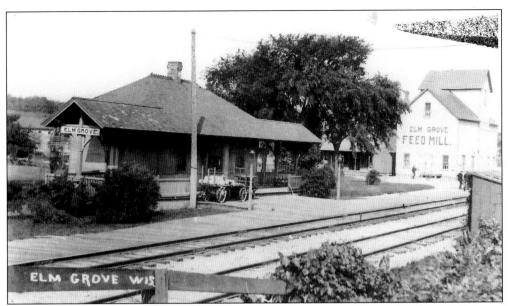

THE ELM GROVE TRAIN STATION, C. 1908. At the beginning of the 20th century, all five of Peter and Sarah Mitchell's sons were working for the railroad. Thomas Mitchell was a railroad fireman, Robert Mitchell was a telegraph operator, William Mitchell and Patrick Mitchell were railroad laborers, and Harry Mitchell was a station agent. Before his death in 1893, father Peter Mitchell, originally from County Galloway, Ireland, had been employed by Wisconsin's railroads since the 1860s. (Author's collection.)

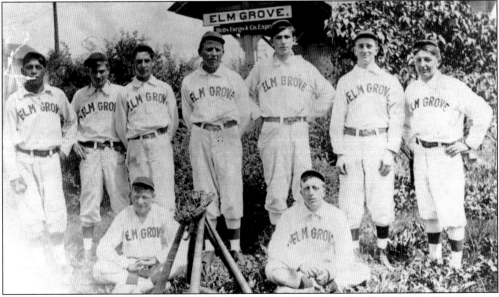

ELM GROVE BASEBALL, 1911. Posing in this image of Elm Grove's village baseball team from left to right are (first row) unidentified and John Spitzer; (second row) "Indian Joe," unidentified, unidentified, George Ramstack, unidentified, Louis Sanders, and Joe Spitzer. On July 30, 1903, the *Waukesha Freeman* reported, "The Elm Grove nine defeated the Brookfielders by a score of 46 to 15, in a recent game. Sunday August 9, the Brookfield team will play in this burg with the home team." (Author's collection.)

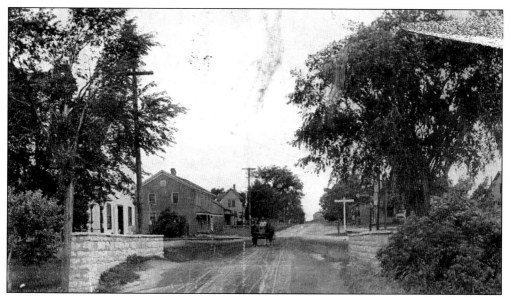

STREET SCENE IN ELM GROVE, C. 1911. Trains passing through the town at high rates of speed were often hazardous for local teamsters. On October 31, 1901, the *Waukesha Freeman* reported, "Matthew Nauertz had a narrow escape Monday while crossing the railway track at Elm Grove with a load of sugar beets. A wheel caught between a plank and rail and was twisted off. Just then the 2 o'clock train was nearly due, and it required work of those about to clear the track in time." (Author's collection.)

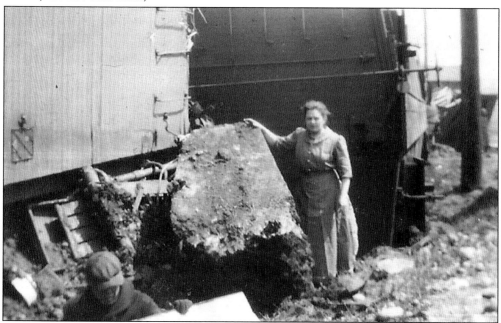

TRAIN WRECK AT ELM GROVE, C. 1915. For the fiscal year ending June 30, 1913, the Railroad Commission of Wisconsin reported 12 individuals killed and 25 injured at grade crossings in the state of Wisconsin along the tracks of the Chicago, Milwaukee and St. Paul Railroad. This train wreck occurred just east of Watertown Plank Road crossing in Elm Grove. (Author's collection.)

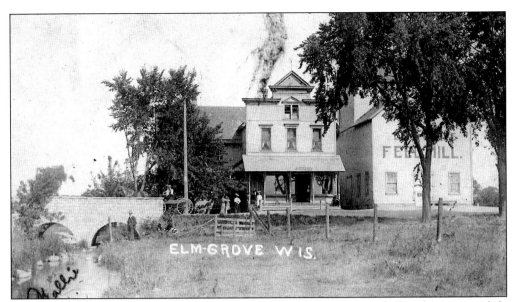

JOHN REINDERS'S STORE AND FEED MILL, C. 1907. Residents visit outside Reinders's store, while a gentleman walks down to take a look at Underwood Creek, which often caused destructive flooding in the spring of each year. On June 28, 1917, the *Waukesha Freeman* reported, "Early Saturday morning the heaviest rain known to residence here fell for about six hours. Water of two-foot depth was running over the road at the bridge. John Reinders & Son sustained a heavy loss to goods." (Courtesy of Doris Haley.)

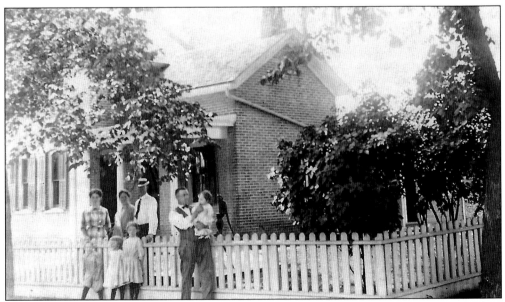

THE CROETHER FAMILY, C. 1920. The Croether family poses for a family picture outside their brick home, which still stands in the village of Elm Grove. Standing in front of the picket fence, from left to right are Willard Croether, Lunette Croether, and Eullyn Croether. Theodore Reusch is holding baby daughter Lorraine. Posing behind the fence are Lizzie, Emma (mother), and Willie (father) Croether. The Reusch family, cousins to the Croethers, ran the Elm Grove Hotel across the road from the Croether home. (Courtesy of Lorraine Reusch.)

THE WOODS IN EARLY SUMMER, C. 1913. In 1915, Brookfield resident Grant Showerman reminisced about the serenity he felt while taking a leisurely walk in the days of his youth, "The woods, they still stand, twenty acres of big timber. Nearly all maple, sloping precipitously toward the north away from the Milwaukee Road and ending in a flat little valley tract and traversed by a rippling little creek fed by several springs and overhung with alder and willow. The lowing of cattle and the perfumed air of June, telling of lush-leafed thickets in the interior, and white lilies and jacks-in-the-pulpit rising from moist woodland soil which exhales warm vapors—these are the impressions you retain of the woods in early summer." (Courtesy of Craig Black.)

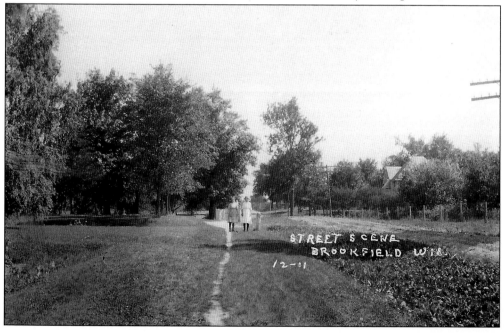

MARGARET GEBHARDT, c. 1900. Born in the village of Rabenshof, Bavaria, Margaret Brendel (1831–1912) came with relatives to America in 1849 and married local farmer John Gebhardt. The couple settled on a 22-acre farm in the town of Brookfield (section 22) where she lived for 62 years. Her husband died in 1877 during a smallpox epidemic. (Courtesy of Armella Sanders.)

GEORGE RAMSTACK (1838–1932) c. 1900. Born in the village of Gemersberg, Bavaria, George Ramstack married Anna Marie Brendel. The family ran a 120-acre Brookfield farm (section 23). The Betzolds, Gebhardts, Pfisters, Ramstacks, Woelfels, Brendels, and Shlenks were members of a large colony of Bavarian Catholics who immigrated to Brookfield during the 1840s. (Author's collection.)

THE ULRICH WOELFEL HOME, 1913. This photograph was taken 68 years after Ulrich Woelfel and his four adult sons left this home in Rollhofen, Bavaria, and immigrated to Wisconsin in 1845. While one son relocated in Chilton, the remaining sons settled in Brookfield and purchased adjoining parcels in section 23, near Elm Grove. (Courtesy of Roger and Marion Woelfel.)

A SWISS COUSIN, C. 1917. This photograph was taken in the village of Horgenbach in Canton Thurgau, Switzerland. The young girl is a cousin to the Hoffman, Wellauer, and Ochsner families, who immigrated to Wisconsin from Canton Thurgau in the late 1840s. All three Swiss families established successful Brookfield farms during the 19th century. (Courtesy of Sally Clarin.)

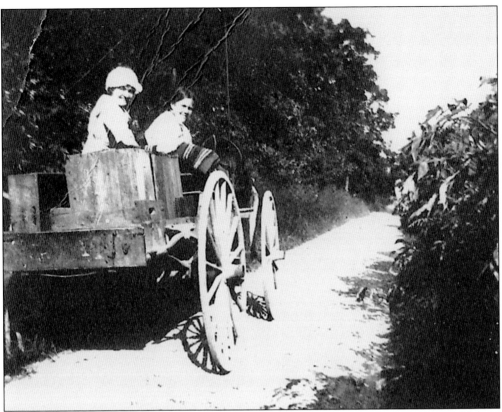

DRIVING ON A COUNTRY ROAD, C. 1910. While returning home to their Brookfield farm (section 20) after dropping off a load of pickles to be brined at the processing plant at Duplainville, Nelson White hopped off the wagon to take this photograph of his daughter Agnes (left) and wife, Jesse. (Courtesy of Craig Black.)

EMERY AND ANNA EBLE FARM, 1912. Dairy cows, sheep, and a good-sized wood pile are seen on the Emery Eble farm in Brookfield (section 29). Don Lussendorf recalled, "Each day, three family members drove the milking herd across the Bluemound Road to pasture after milking, and the sheep would follow." Eble family members shown are Ray (left) and George sitting in the buggy, while Emery Eble (father) stands next to the woodpile. (Courtesy of Elaine Moss.)

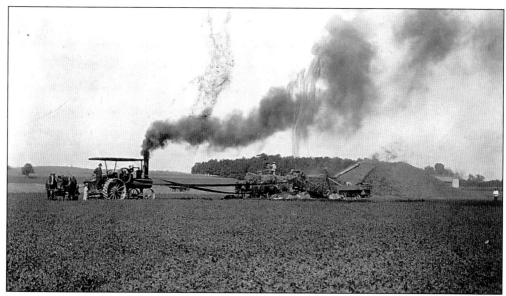

THE MATT GEBHARDT THRESHING COMPANY, 1912. The Matt Gebhardt threshing operation moved from farm to farm in the fall. Work crews often slept in the local farmer's barn. The *Waukesha Freeman* reported on October 8, 1903, "The Gebhardt Threshing Co., threshed 2,797 bushels of grain, viz.: 1,066 bushels of barley and 1,731 bushels of oats, in 6 hours and 40 minutes on Monday last for Fred Mierow. Mr. Mierow says if the pitchers hadn't got out of wind they could have threshed seven hundred bushels more in the same length of time." (Courtesy of Roger and Marion Woelfel.)

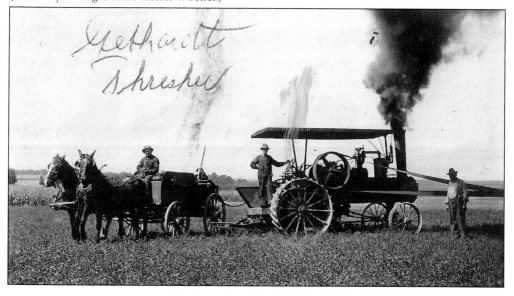

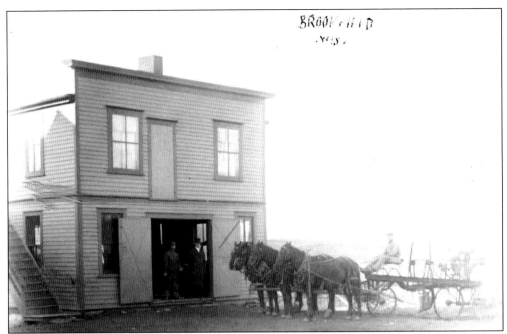

WILLIAM HUBERTY'S BLACKSMITH SHOP, C. 1913. William Huberty ran a blacksmith shop in the village of Brookfield during the early 1900s. On January 26, 1905, the *Waukesha Freeman* reported, "William Huberty, the village blacksmith, was hurt from an accidental blow from a sledge, and was unable to walk the following day." In this image, a driver from the village pulls up to Huberty's shop driving a road grader pulled by a four-horse hitch. (Courtesy of Arline Kirkham.)

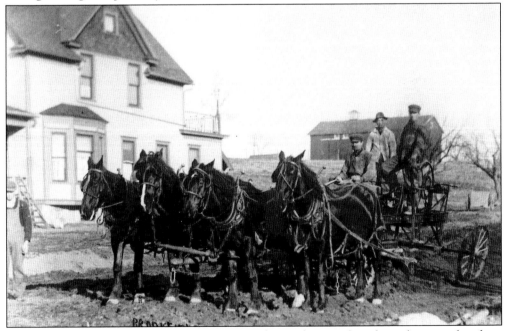

MAKING A ROAD, C. 1913. A road crew is completing the initial grade work required to form Pleasant Street in the village of Brookfield. The Ida Becker home is on the left. (Courtesy of Craig Black.)

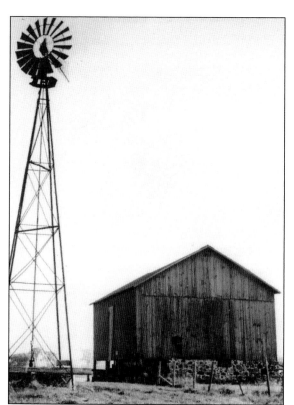

A WINDMILL, C. 1930. Water-pumping windmills became popular in Wisconsin beginning in the 1880s. This windmill on the Anton Svehlek farm (sections 20 and 21) was transported to the Svehlek farm from the Abraham Basting farm during the 1920s. (Courtesy of Larae Svehlek.)

THE OLD ELM TREE, C. 1934. For decades, elm trees graced both sides of Watertown Plank Road leading into the village of Elm Grove. Before the spread of Dutch elm disease into the community during the 1950s, local residents compared traveling beneath the tall overhanging branches to traveling through a magnificent cathedral. (Courtesy of Craig Black.)

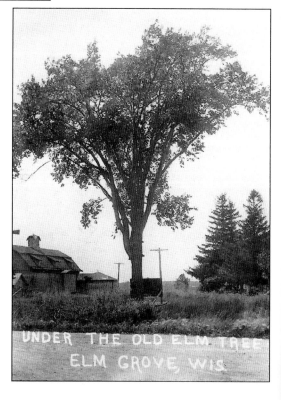

Six
THE TORNADO OF MAY 31, 1914

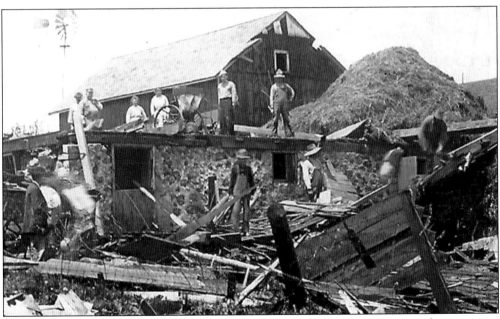

THE ALFORD KNOP FARM, 1914. Tornadoes could be devastating to Wisconsin farmers, since most farmers rarely carried enough insurance to cover the cost of rebuilding in cases of total destruction of farm buildings. They were often forced to depend on the support of neighbors or sell out. Neighbors appeared shocked as they peered around and saw the devastation on the Alford Knop farm (section3). The barn was destroyed, machinery was damaged, hay was strewn about, and the silo was twisted and tipped. The house received little damage. The Alfords stayed and rebuilt. By 1918, Alford and Louise Knop owned a 50-acre Brookfield farm, three workhorses, and nine dairy cows. (Courtesy of Elmbrook Historical Society.)

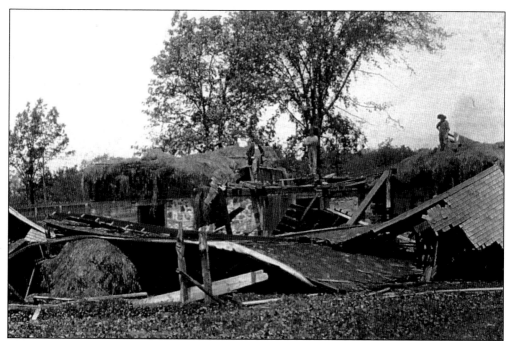

THE CECILIA FREDERICK FARM, 1914. Neighbors come to assess the damage on the Cecilia Fredrick farm in Brookfield (section 5). The barn is totally torn to pieces while the stored hay lies scattered and drenched in rainwater. (Courtesy of Elmbrook Historical Society.)

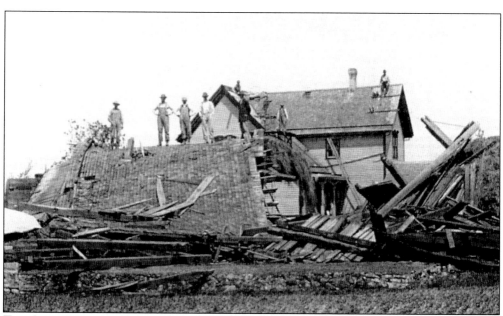

THE CARL KIRKHOFF FARM, 1914. A shed and barn were torn to pieces on the Carl Kirkhoff farm in Brookfield (section 4). The house appeared to receive minor damage as neighbors repair shingles torn from the roof. In 1918, Kirkhoff purchased a new 80-acre farm in Menomonee Falls. He had three children, six horses, and 19 dairy cows. (Courtesy of Elmbrook Historical Society.)

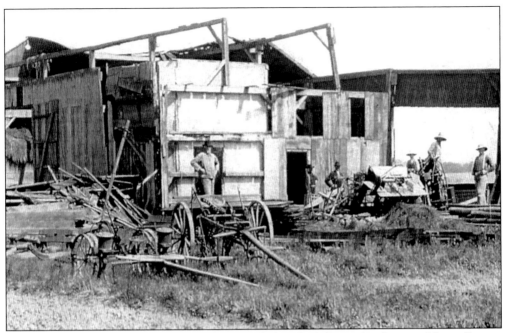

THE JOHN ZEMPLE FARM, 1914. The John Zemple farm had the roof and most of the walls torn off the barn. Machinery was pulled from the barn, while beams and lumber were strewn about the farmyard. By 1918, John and Sophia Zemple purchased an 80-acre farm in Pewaukee. They owned three workhorses and 14 dairy cows. (Courtesy of Elmbrook Historical Society.)

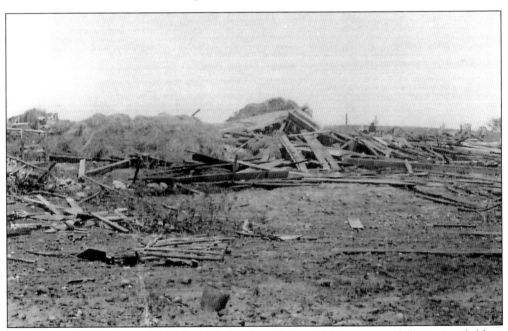

JACOB LIVINGSTON FARM, 1914. In 1910, Jacob and Minnie Livingston and their nine children ran a small farm near Brookfield Heights (section 4). The tornado left no buildings standing on the farm. It is not known what became of the Livingston family following the horrific storm. (Courtesy of Elmbrook Historical Society.)

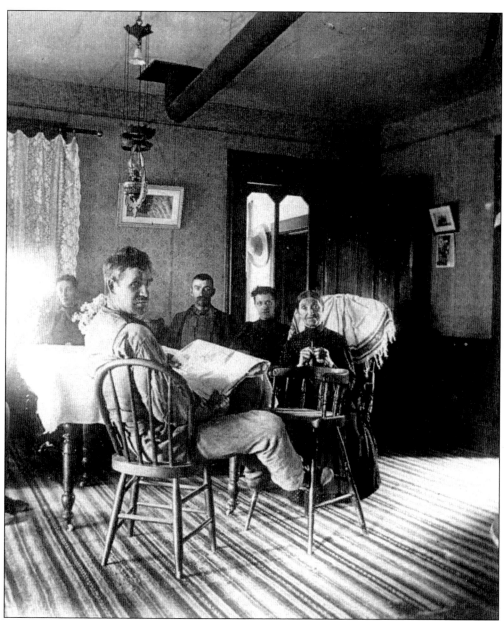

THE AUGUST BOLTER PARLOR, C. 1914. During the early 1870s, Wilhelm and Wilhelmina (Falk) Bolter of Germany purchased a 120-acre Brookfield farm (section 21). Their children were Charles, Henrietta, August, Millie, Minnie, Alice, and Mamie. It may have been Wilhelmina, at age 59, who wrote the following as she observed her family gathered about in the parlor on November 6, 1881: "Minnie is in the rocking chair. Millie is sitting at her feet. Caroline is sitting at the table looking at autographs. Matilda is at the table and Fred is at her side. Cousin Amelia is leaning on the bed. Alice is on a chair near by. August is standing in the door. Where will we be in 10 years from to-day? Will we be the same as now?" About 33 years later, the parents have passed on and the children have become adults. Two appear in the image above. Sitting around the parlor table from left to right are Alice Bolter, August Bolter, John Spencer, Mayme Bolter (August's wife), and Minnie Falk. (Courtesy of Arline Kirkham.)

FRED GOERKE, C. 1914. Fred and Margaret Goerke immigrated to Wisconsin from Prussia during the 1840s. By the early 1860s, he purchased the Plank Road house. On June 26, 1902, the *Waukesha Freeman* reported, "A very pleasant party was given at the Junction House Thursday evening. It was the fortieth anniversary of the day when Fred Gehrke entered the hotel business." From 1885 to about 1895, the community was referred as Blodgett for Chester A. Blodgett, who kept the community's post office. However, it was the Goerke name that stuck, as this location remains identified today as Goerke's Corners. (Courtesy of Waukesha County Historical Society and Museum.)

MARGARET GOERKE, C. 1914. Fred and Margaret Goerke had seven children—John, Mata, Amanda, Fritz, Eddie, Grover, and Reuben. The *Waukesha Freeman* reported on December 17, 1903, "Don't forget that a telephone pay station has been placed in Fred Goerke's Junction House to accomodate the public." (Courtesy of Waukesha County Historical Society and Museum.)

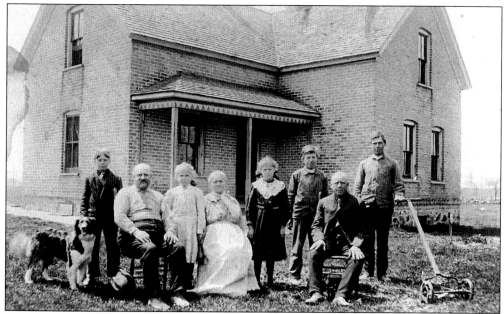

THE ANTON SVEHLEK HOME, C. 1914. Anton Svehlek was an immigrant farmer from Bohemia (Czechoslovakia). He owned a Brookfield farm (sections 21 and 22). His wife's name was Pheophilia. Svehlek family members posing in this image from left to right are Leo, Anton (father), Amelia, Pheophilia (mother), Clara, William, Amil (Anton's brother), and George (showing off the family's new lawn mower). (Courtesy of Larae Svehlek.)

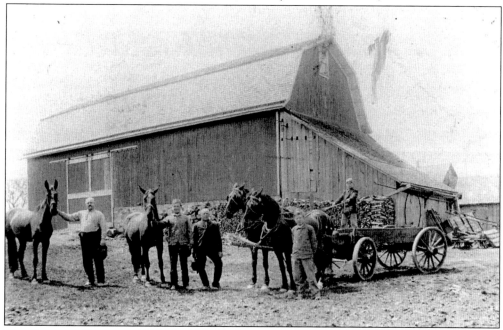

THE SVEHLEK BARN, C. 1914. Svehlek family members posing with their humble draft horses, from left to right, are Anton, Frederick "Fritz" (Anton's son), Amil (Anton's brother), and Anton's sons George and William, who are driving a wagon and unloading winter wood alongside the barn. (Courtesy of Larae Svehlek.)

THE FARMER'S AXE, 1913. A great amount of a Brookfield farmer's time was spent cutting wood for fuel. In this image, Roy Eble, the youngest son of Emery and Julia Eble, brings firewood into the house to be placed in the wood box next the stove. (Courtesy of Elaine Moss.)

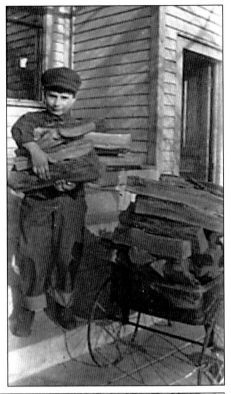

THE WOOD LOT, C. 1927. Most Brookfield town farmers maintained a wood lot from which they could cut wood for cooking and heating their homes in the winter months. The *Waukesha Freeman* reported on April 5, 1900, "Our bachelor friend Chris Galapinski [Brookfield, section 27] cut his foot severely with an ax, and kept on working in the woods." (Author's collection.)

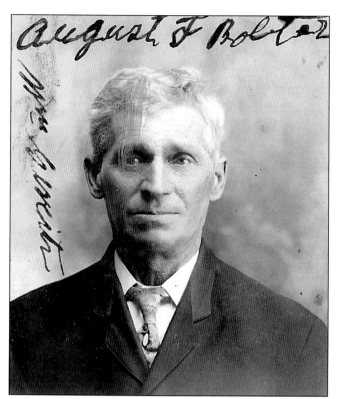

AUGUST F. BOLTER, 1918. When August F. Bolter (1856–1956) reached 100 years of age, on January 5, 1956, the *Waukesha Freeman* wrote the following account of his recollections of earlier days: "August enjoyed taking those long trips in the summer months to Milwaukee. He remembered the Haymarket well. He took over 120 tons of loose hay to Milwaukee in one year with a team carrying 1 1/2 tons on a load." Milwaukee's haymarket was located on Fifth and Vliet Streets. (Courtesy of Evelyn J. Nicholson.)

LEADING A STEER TO PASTURE, 1915. Emery B. Eble escorts a steer with a sure rope on his farm (section 29), as his wife, Julia, looks on from the barn door. On July 1, 1909, the *Waukesha Freeman* reported, "Emory Eble has a rye field that is among the top notchers. The stalks measure 6 feet and 5 inches in length." (Courtesy of Elaine Moss.)

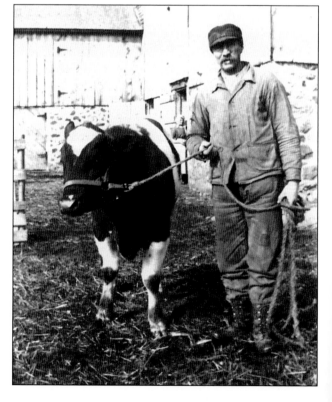

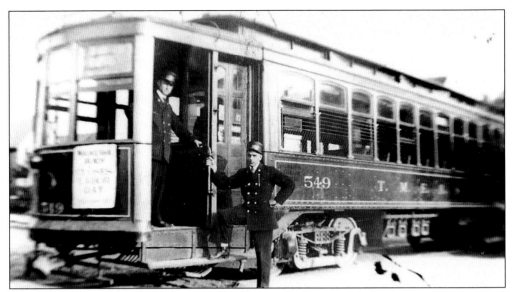

THE INTERURBAN, 1916. The Milwaukee Electric Railway and Light Company constructed its new electric interurban rail line through nearby New Berlin in 1897. At its completion, Brookfield passengers could get on or off the interurban at the Mooreland, Sunnyslope, or Calhoun stations in New Berlin. Standing at the front of the car is Edward Reith, a motorman for the rail company. (Courtesy of Gene Nettesheim.)

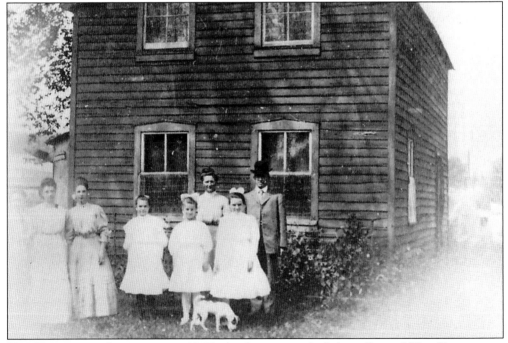

THE TELEGRAPH OPERATOR, C. 1915. At the west end of the village of Elm Grove was a small home occupied by William and Ida Olson, immigrants from Norway. William Olson was a telegraph operator for the railroad. At the left are three of Ida Olson's sisters, and the three young girls are Elsie Reinders, ? Dwyer, and Gertrude Reinders. Standing in back are William and Ida Olson. (Courtesy of Craig Black.)

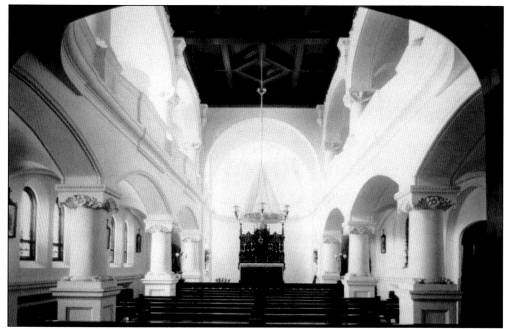

A JUBILEE, 1909. During the summer of 2008, the School Sisters of Notre Dame held a jubilee in celebration of their 150 years of service at Elm Grove. On July 2, 1909, the *Waukesha Freeman* provided the following account of their 50-year anniversary at Elm Grove: "In the sermon Monsignor Abbelen called attention to the growth of the institution from an insignificant beginning to one of commodious proportions." The above view shows the chapel of St. Joseph in Notre Dame Hall. (Courtesy of School Sisters of Notre Dame.)

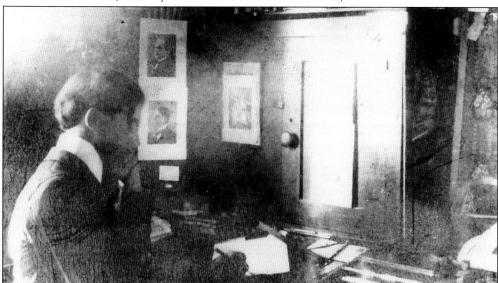

NELSON WHITE, C. 1915. The Bureau of Internal Revenue was formed in 1862 as a means of collecting an income tax to pay for war expenses. In this image, Nelson White, the son of Almond and Jessie White of Brookfield (section 20), is seen working at his desk at home while employed as a cashier for the U.S. Revenue Office in Milwaukee. In 1953, the bureau became known by its modern name, the Internal Revenue Service. (Courtesy of Craig Black.)

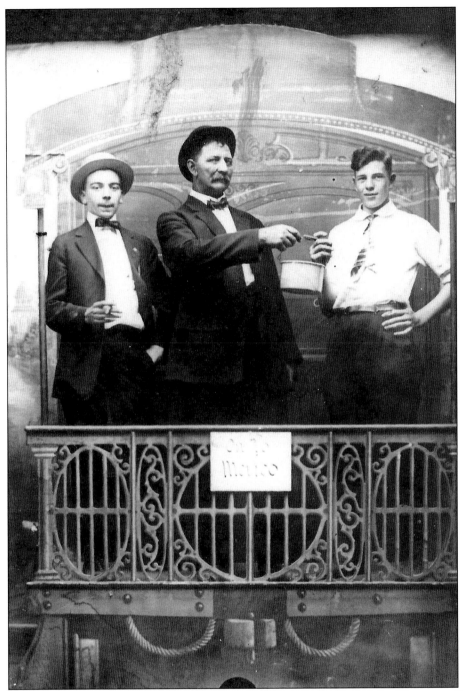

THE WISCONSIN STATE FAIR, C. 1917. Brookfield farm families attended the Wisconsin State Fair at West Allis in large numbers, primarily due to the fact that the function of the fair in earlier years was so closely tied to agricultural interests with which they had a vital connection. Most of Wisconsin's workforce today does not share such a focus. From left to right, three boys from Brookfield, Simon Ramstack, George Gebhardt, and Charles Sanders, enjoy a tin bucket of beer and cigars at the Wisconsin Sate Fair. (Courtesy of Armella Sanders.)

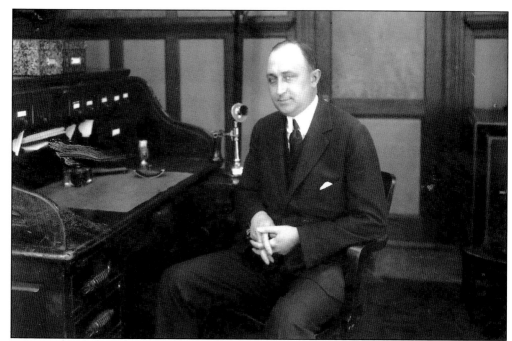

TRIANGLE FILM CORPORATION, C. 1917. Harry and Roy Aitken, who were born and raised on a Brookfield farm (section 30), played a key role in the early development of the motion picture industry. With their formation of Keystone Pictures in 1912, the Aitken brothers helped to ignite the careers of Charlie Chaplin, Mary Pickford, Lillian Gish, and others. Roy Aitken (above) poses at his desk in his office at Triangle Films in Hollywood. Harry Aitken (below) may be driving a foreign automobile in Europe, as his biography suggests he spent much time there between 1915 and 1917. (Courtesy of Waukesha County Historical Society and Museum.)

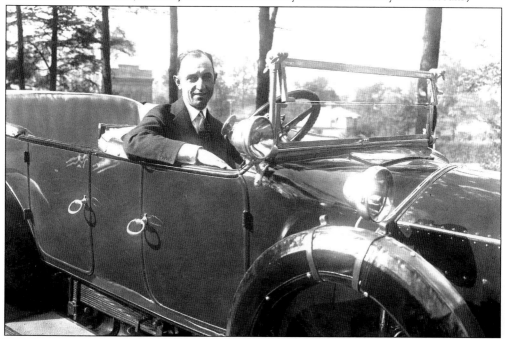

DANIEL AND EMMA SCHEIBE, 1918. Third-generation Scheibe sons broke up the original family farm into smaller parcels. Daniel and Emma Scheibe had two children in 1918 and owned a 50-acre Brookfield farm (section 13) along the town line road, today's 124th Street. (Courtesy of Mary Scheibe.)

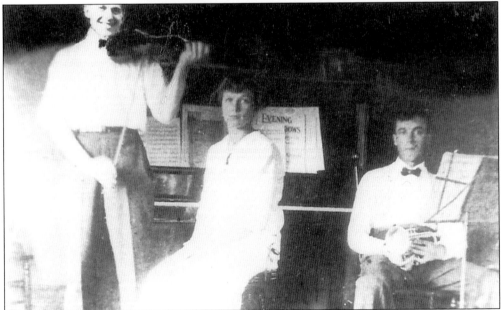

FAMILY MUSIC, 1915. Reiner and Lena Nettesheim of Brookfield (section 7) encouraged their children to develop skills in music. Playing in the family parlor, from left to right, are Conrad (on the fiddle), Mary (playing the piano), and Adolph (resting his trumpet). One of the pieces of music, "Evening Shadows," seen on Mary's piano, was published by Czech composer Josephina Brdlikova in 1892. (Courtesy of Gene Nettesheim.)

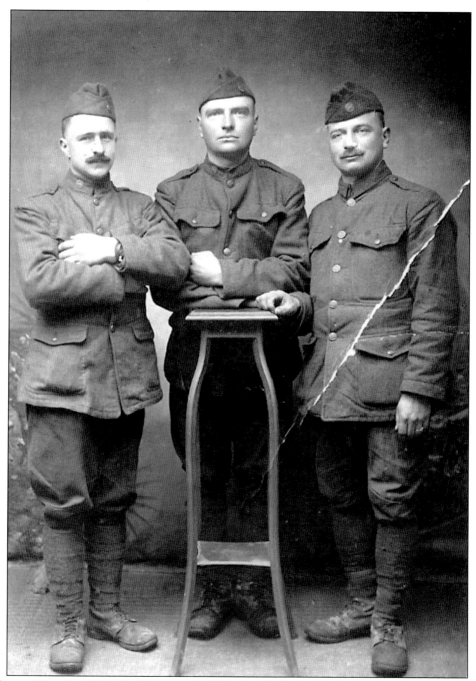

WORLD WAR I, 1918. On February 6, 1919, the *Waukesha Freeman* reported, "Pvt. George Bresnan, who has been overseas for over a year, stopped at the Behling home, at Elm Grove, for a couple of days last week enroute to his home at Madison, Minn. While in the service he was wounded in the foot with a piece of shrapnel and was gassed. He was in a hospital in France for two months." As members of Wisconsin's 32nd Red Arrow Division, (from left to right) George Reinders, John Ramstack, and Joseph Ramstack of Brookfield were photographed in France in 1918. (Author's collection.)

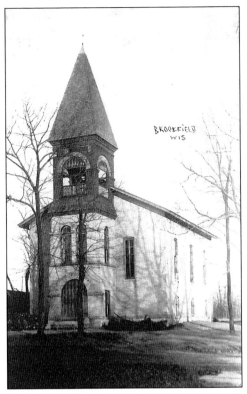

THE METHODIST CHURCH, C. 1923. In 1934, Grace Kieckhefer recalled, "Carrie Thatcher's father built their family home in 1883 on the Brookfield Road, almost opposite the Methodist Church. Social life revolved around the Church across the road. She recalled the prayer meetings and choir practice, the Christmas programs, the constant stream of pies and cakes and hot dishes, whereby the church, somehow, eked out their meager budgets." (Courtesy of Arline Kirkham.)

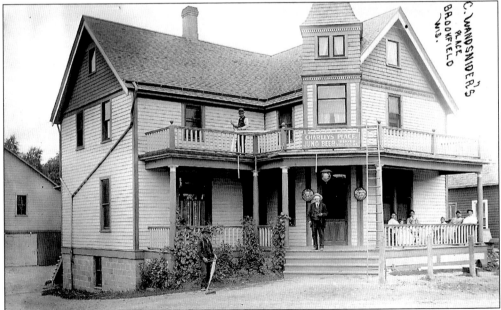

CHARLIE'S PLACE, C. 1920. In 1977, Frances (Huberty) Schmidt recalled, "You dressed in your Sunday best and took the whole family for a good time when you went to Uncle Charlie Wandsnider's Dance Hall, in the village of Brookfield [section 17]. Sometimes there were orchestras, but usually the music was provided by a rousing concertina as played by Bill Krueger or Ervin Andree." (Courtesy of Elmbrook Historical Society.)

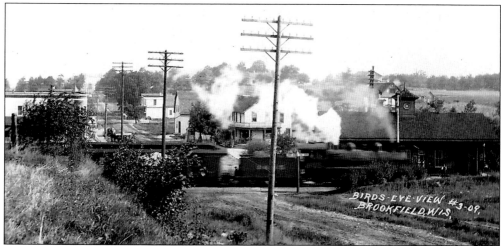

HEAVY TRAIN TRAFFIC, C. 1916. In the early years of the 20th century, the town of Brookfield witnessed much heavier train traffic than most other Wisconsin communities. This was largely due to the fact that two major branches of the Chicago, Milwaukee, and St. Paul Railway ran through the town. By 1900, traffic over both lines was extremely heavy. In 1912, 21 westbound and 25 eastbound trains reportedly ran through Brookfield daily, along with several extra trains. (Courtesy of Arline Kirkham.)

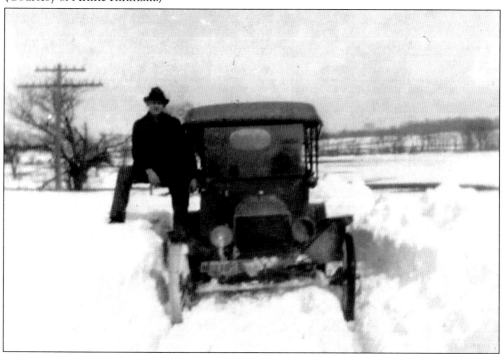

A HEAVY SNOWSTORM, 1923. The *Waukesha Freeman* reported on April 17, 1921, "Mr. and Mrs. George Bresnan opened their doors to fourteen snow-bound motorists last Saturday night, who enjoyed their hospitality until late Monday afternoon, when with horses and sleighs they were safely taken to the train at Elm Grove and returned to their homes at Merton, Watertown, and Oconomowoc." In this image, an Elm Grove resident has his Ford Model T stuck during the same storm. (Author's collection.)

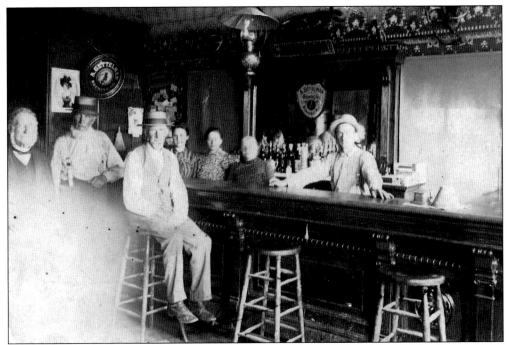

THE ELM GROVE HOTEL, C. 1915. The *Waukesha Freeman* reported on January 30, 1902, "Theodore Reusch was in Milwaukee over Sunday and was made an honorary member of the Pabst club. The stuff that made Milwaukee famous was unto water at Brookfield in the glad freshet time." Appearing in this photograph in front of the bar are three unidentified men. Behind the bar from left to right are a hired girl, Elizabeth Reusch, Christina Reusch (mother), and Theodore Reusch. (Courtesy of Lorraine Reusch.)

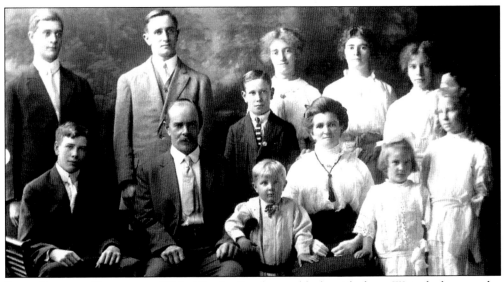

JOHN SANDERS FAMILY, C. 1915. Charles Sanders, a blacksmith from Waterford, opened a blacksmith shop at Elm Grove (section 25) in 1915. Family members from left to right are (first row) Charles, Charles Sr. (father), Joseph, Catherine (mother), Catherine, and Henrietta; (second row) John, Louis, William, Mary, Frances, and Margaret. (Courtesy of Armella Sanders.)

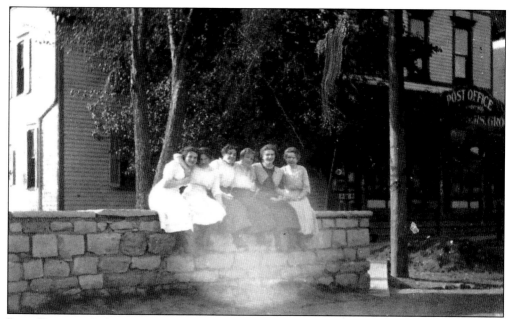

JOHN REINDERS'S GROCERY, 1910. In the background is a view of the old Reinders grocery before being remodeled and enlarged. Reinders family members pose on the old stone block wall over Underwood Creek. From left to right are Gertrude, Elsie, Mary, Margaret (mother), unidentified, and Clara. As the Elm Grove Post Office was run out of John Reinders's store, village residents typically took a daily walk to the store to pick up their mail. (Courtesy of Doris Haley.)

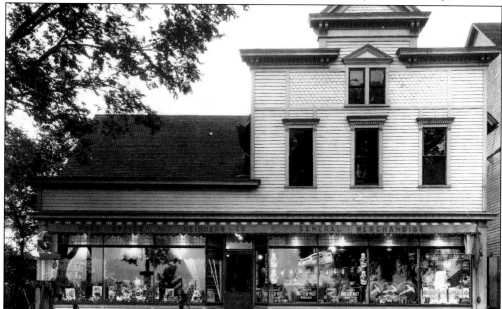

JOHN REINDERS'S GENERAL STORE, 1925. In 1976, George Reinders recalled the grocery operation of his father, John Reinders, in Elm Grove (section 25) from the 1920s, "We sold everything from needles to threshing machines. In the early years, customers bought meat at the right side, groceries at the left, picked up mail in the middle of the store toward the back, and hiked upstairs to try on 'Meyers' shoes and boots." (Courtesy of Doris Haley.)

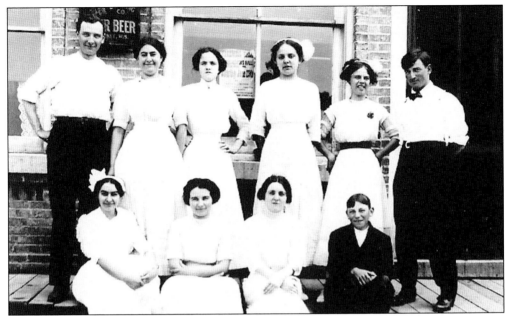

A FAREWELL GATHERING, 1919. The children of Frank Ramstack held a retirement party for their father, as seen in this image. Posing from left to right on the wooden sidewalk are (sitting) Mamie Hastrich, Frances Ramstack, Lydia Theis, and Simon Ramstack; (standing) Conrad Ramstack, Eleanor (Hastrich) Ramstack, Alma Theis, Veronica Ramstack, Helen (Phillips) Ramstack, and Joseph Ramstack. In 2009, this same tavern goes by the name O'Donahue's Irish Pub. (Author's collection.)

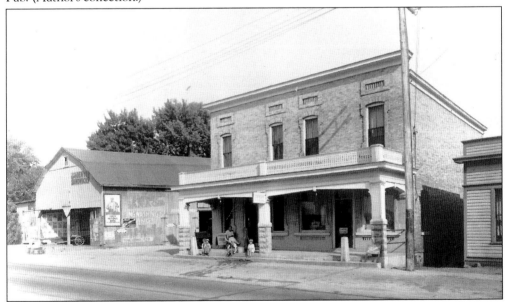

PROHIBITION, 1925. In this image, the front of Joseph Ramstack's tavern in Elm Grove takes on a rather innocent small-town appearance. The proprietor is advertising Bloomer's Ice Cream and Denver Sandwiches. However, on May 1, 1929, the *Milwaukee Journal* wrote that Joseph Ramstack was "held for trial Wednesday under the Jones law which provides a maximum penalty of five years in prison for the illegal sale of alcoholic beverages." (Author's collection.)

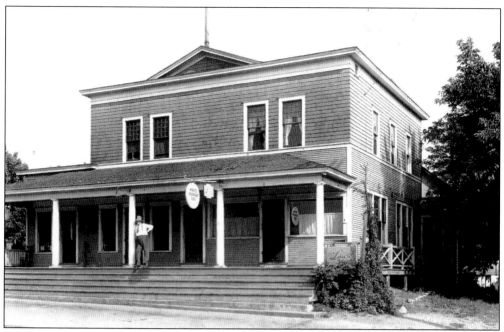

THE AUTO INN, C. 1915. Proprietor Edward Ramstack proudly poses on the porch of his new Elm Grove hotel. On December 13, 1914, the *Waukesha Freeman* reported, "E. Ramstack moved into the new hotel Thursday night. He will have a formal opening next Thursday night when he will give a Sylvester Eve ball." (Courtesy of Myrna Ramstack.)

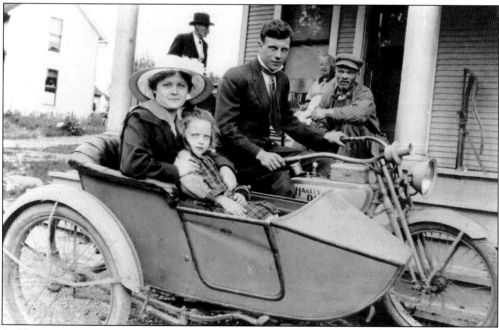

A HARLEY-DAVIDSON MOTORCYCLE, C. 1919. While parked in front of Edward Ramstack's tavern at Elm Grove, Ben Marks poses with sisters Martha (left) and Myrna Ramstack on his Harley with a sidecar. The tavern stood just to the east of the railroad tracks on the south side of Watertown Plank Road. (Courtesy of Myrna Ramstack.)

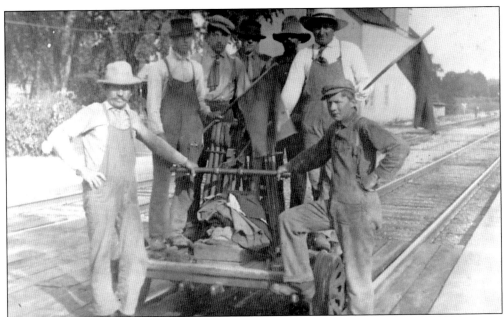

A HAND-PUMPED RAILROAD CAR, C. 1920. A track repair crew made up of local men poses in front of John Reinders's mill at Watertown Plank Road crossing at Elm Grove. On September 24, 1914, the *Waukesha Freeman* reported, "M. Nass of Portage is assisting Gilbert Johnson, who has charge of a gang of men making repairs at the Elm Grove freight yards. Albert Goldbeck is acting as flagman at the railroad crossing for a short time." (Courtesy of Myrna Ramstack.)

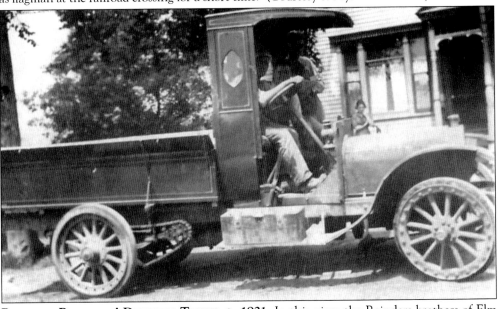

REINDERS BROTHERS' DELIVERY TRUCK, C. 1921. In this view, the Reinders brothers of Elm Grove (section 25) deliver merchandise in a one-ton chain-driven Ford truck. Previous to motor power, the Reinders brothers depended on horsepower. The *Waukesha Freeman* reported on October 22, 1903, "The wagon of W. Smith, the genial teamster for John Reinders, slewed and fell with a large box of lamp chimneys in such a manner that the front wheel went over both of his limbs." (Courtesy of Doris Haley.)

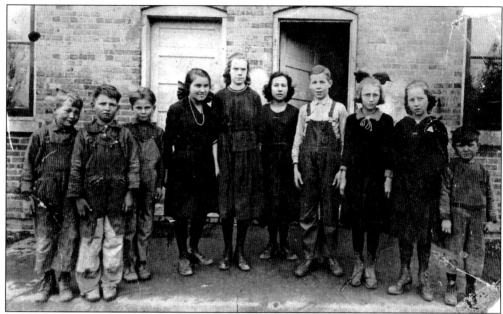

DIXON SCHOOL, 1925. This is the entire enrollment for Dixon School during the 1924–1925 school year. The students from left to right are Dave Hahm, Joseph Bobrowitz Jr., George Kleinshmidt, Gladys Geinke, Janny Hahm, Beatrice Anski (teacher), Harold Hahm, Elsie Kleindchmidt, Elizabeth Hahm, and Andrew Bobrowitz. They are facing North Avenue on the north side of the building. (Courtesy of Ann Pichler.)

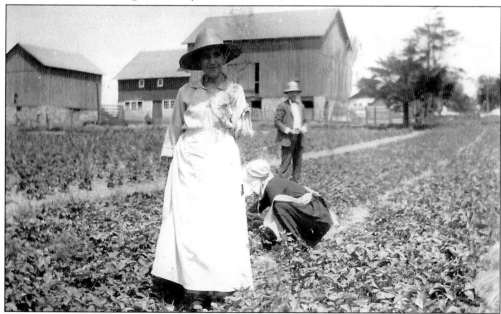

PICKING STRAWBERRIES, C. 1930. Working in the large strawberry patch on the Mitchell brothers' farm in Brookfield (section 18) are Henrietta (Bolter) Behling, Minnie (Bolter) Mitchell (crouched down), and Herbert Behling. The Mitchells, like most other Brookfield farm families, maintained large gardens, which was of great benefit during the Depression. (Courtesy of Evelyn J. Nicholson.)

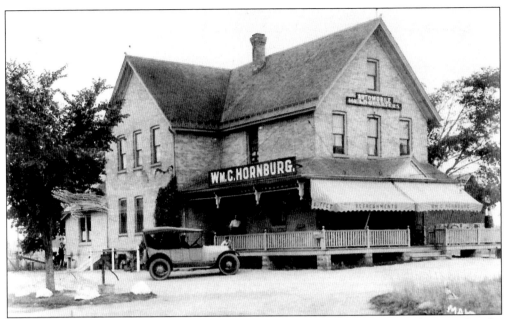

AUTOMOBILE HEADQUARTERS, C. 1924. William Hornburg ran a tavern at what is today the northeast corner of Bluemound Road and Pilgrim Parkway in Elm Grove. During the 1920s, area tavers were catering to a quickly growing automobile clientele. As a result, many taverns like Hornburg's found a way of incorporating "automobile" or "motor-inn" into their names. (Courtesy of Arline Kirkham.)

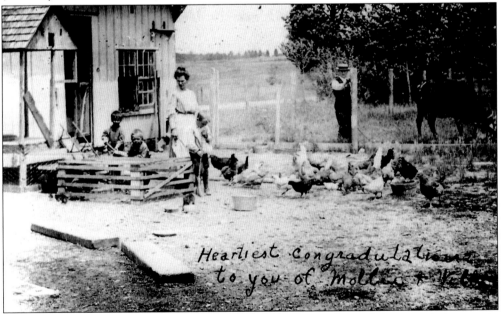

THE HORNBURG FAMILY, C. 1926. This postcard, apparently mailed to a relative, reads, "Heartiest congratulations to you of Mollie and Will." Pictured from left to right, the Hornburg family, tending to their chickens and a cow, are Harold, unidentified, Amelia (mother), Elmer, and William (father). In the background, barely visible, is Watertown Plank Road. (Courtesy of Arline Kirkham.)

HORSE POWER, C. 1925. In 1981, Charles Phillips wrote, "In the nineteenth century horses served the key role in Waukesha County, furnishing the power to pull plows, drags, seeders, cultivators, mowers, binders, grain and hay wagons and the lowly manure spreader. They were our original 'horse power.'" Showing off a couple of horses on the Simon Woelfel farm are Matthew Woelfel (left) and Samuel Gebhhardt. (Courtesy of Roger and Marion Woelfel.)

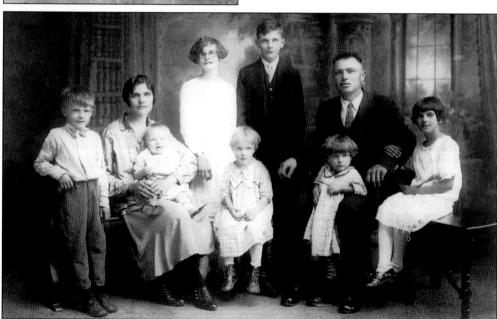

THE BROJANIC FAMILY, 1926. Paul Brojanic, born in Dubrovnik, Croatia, in 1893, and his wife, Kata, born in Spi Bucovica, Croatia, in 1889, came to America in 1912. In 1933, they purchased the John Gebhardt farm in Brookfield (section 22). From left to right in this family photograph are Louis, Kata (mother, holding the baby Tony), Christine, Helen, John, Paul (father), Mary (in front of her father), and Ann. (Courtesy of Ann Pichler.)

Seven
ELM GROVE FAIR

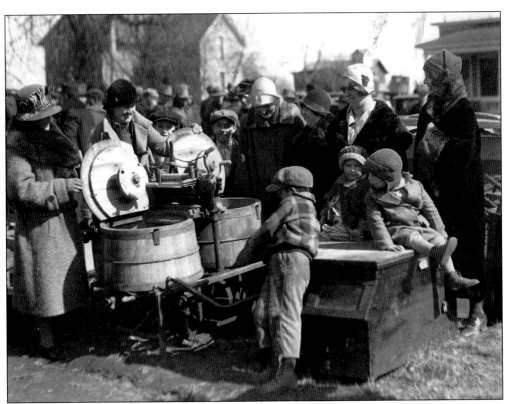

BLUE MONDAY, MARCH 31, 1927. George H. Reinders of Elm Grove and auctioneer Rudy Domain organized the first Elm Grove Fair. The fair was held in a vacant field on the east side of the railroad tracks where today's Legion Drive runs north from Watertown Plank Road. Ogling the double tub "women's friend" machine, from left to right, are Mrs. Manty, wearing a small black hat and a large smile; Ann Wanvig, in the center; and Leona Hoffman, the taller lady wearing a white hat. (Courtesy of Doris Haley.)

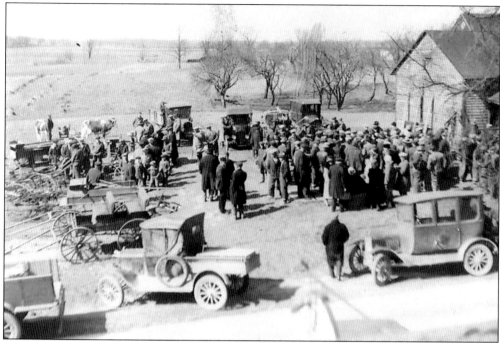

ELM GROVE FAIR, MARCH 31, 1927. Up for auction are wagons, machinery, a scale, a DeLaval Cream Separator, and livestock. The group standing in a crowd at right is listening Rudy Domain, "the best auctioneer Brookfield has ever known," enticing residents to barter on an unidentified item. (Courtesy of Doris Haley.)

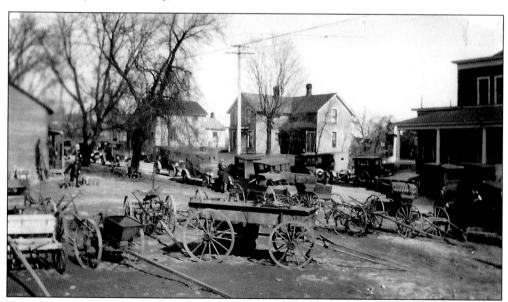

FARM MACHINERY, MARCH 31, 1927. Cars are parked along both sides of Watertown Plank Road where people browsed cultivators, hay rakes, planters, and buggies. From left to right, the buildings are Edward Ramstack's tavern and home and Theodore Reusch's home. The small building on the north side of the road was once owned by William Hinze. (Courtesy of Doris Haley.)

CHECKING OUT A HORSES AGE, MARCH 31, 1927. At the Elm Grove Fair, several "fellers" are looking at a horse put up for auction. Apparently one could get a good estimate of a horse's age by looking at the quality of its teeth. However, according to Charles Phillips, "You never really knew what kind of work horse you really had until you actually got it in harness and out in the field." (Courtesy of Doris Haley.)

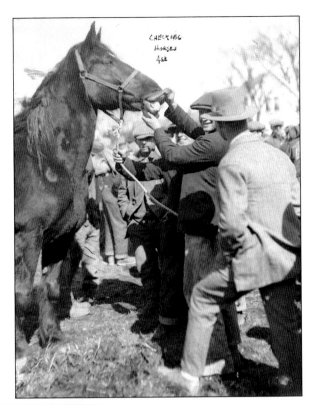

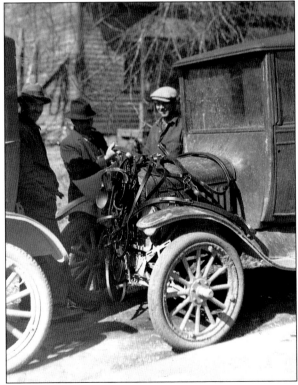

TAKING A GOOD LOOK AT A HARNESS, MARCH 31, 1927. From left to right, John Stiger, John Doman, and George Nauertz are checking out a harness laid out on top of the engine of a 1921 Ford Model T sedan. As late as 1909, Chris Bush made and repaired harnesses for local farmers in his small shop attached to Theodore Reusch's tavern in Elm Grove. (Courtesy of Doris Haley.)

THE BASTING DAIRY HERD, C. 1924. Abraham and Magdeline Basting owned a 115-acre farm and 14 Holsteins on their Brookfield farm (section 8) in 1918. Several other Brookfield farmers who developed award-winning herds during this period included the Pfister brothers' Brown Swiss herd, Adda Howie's Jersey herd, and the large Holstein herds of Luis Voeltz, William Leonard, the Mitchell brothers, and the Aitken brothers. (Courtesy of Patricia Basting.)

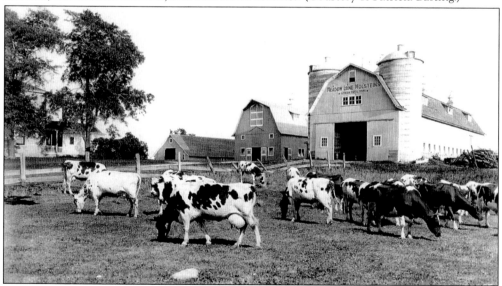

MEADOW LANE HOLSTEIN FARM, C. 1928. On April 22, 1921, the *Waukesha Freeman* reported, "Harry and Roy Aitken, prominent moving picture men of New York and Waukesha, are consigning to the Waukesha Holstein sale on Monday, April 25, a five-year-old cow, whose dam won the grand championship at the Waukesha Dairy Show, 1921. Aitken Brothers are also consigning a son of the 40-lb. bull, King Bess Johanna Ormsby, whose dam, Bess Johanna Ormsby is world champion over all ages and all breeds." (Courtesy of Historic Photograph Collection/Milwaukee Public Library.)

ADDA F. HOWIE, 1928. On November 25, 1914, the *Arizona Prescott Journal-Miner* reported, "Mrs. Adda F. Howie, is one of the most famous women in the United States—one about whom, more has been written and printed in this and foreign countries than about any other woman now living and who is engaged in an industrial pursuit for the benefit of the country and humanity in general. She has won her medal as a result of practical experience, being known throughout the dairying world as the breeder and importer from the Jersey Islands of blue ribbon Jersey stock. On her dairy farm, called 'Sunny Peak Farm,' near Elm Grove, Wisconsin, she has a herd of eighty-four head bred on the farm. She started this herd twenty years ago, and it is today recognized as the very finest herd in the entire country." (Courtesy of Waukesha County Historical Society and Museum.)

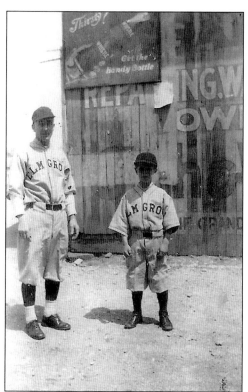

ELM GROVE BASEBALL, 1928. Manager Toney Neuman and batboy Joseph Ramstack Jr. pose in front of Joseph Ramstack Sr.'s large barn in Elm Grove. (Author's collection.)

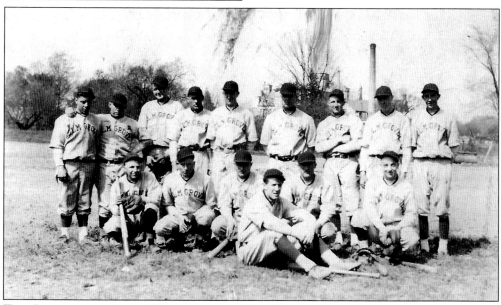

THE CRACK OF THE BAT, 1928. Members of the 1928 baseball squad pose for a team picture at their diamond located behind Edward Ramstack's tavern in Elm Grove. In 1986, Joseph Ramstack Jr. recalled, "Joseph Sanders could cover the whole outfield all by himself. He had a glove that didn't have any padding, just plain leather, and he oiled it down. But, he had big long legs. He would be off at the crack of the bat and he always seemed get there and catch it just at the last possible moment." (Author's collection.)

THE MOUND KENNEL CLUB, 1930. Al Capone had a Chicago newspaper reporter fixing bets for him at the Mound Kennel Club, a dog track, which was located on Blue Mound Road in Brookfield (section 26). Soon after, the reporter was shot and killed by members of George Clarence "Bugs" Moran's gang—Capone's archenemies. Police arrested at least one Moran gang member, Jack Zuta (at right), who escaped and hid in Waukesha County. In turn, on August 1, 1930, Zuta was shot and killed by unspecified Chicago gang members at the Lake View Resort in Delafield. (Courtesy of Chicago Police Department.)

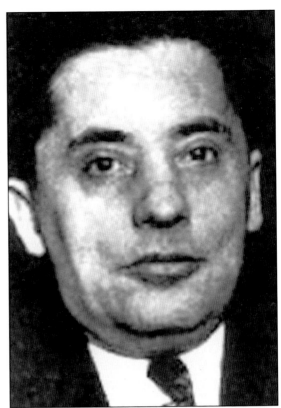

THE AL CAPONE HOUSE, 1993. In 1998, Raymond Becker gave a talk for the Elmbrook Historical Society on his home. Many local old-timers are convinced this house was directly connected to Al Capone. Becker recalled, "The house was used as a safe house where gangsters might stay overnight and, above the front door, was a guard house with a tower which held machine guns and several barrels of 'Old Crown Whisky.'" (Courtesy of Arline Kirkham.)

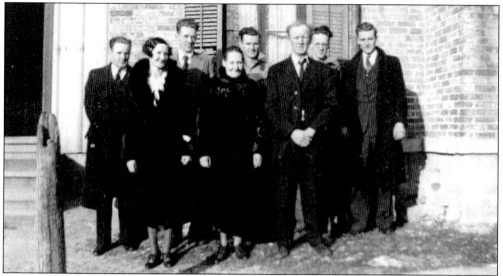

THE BASTING FAMILY, C. 1940. In December 1879, Abraham Basting of Zealand Caston, Holland, his wife, Cornelia, and their three children immigrated to Wisconsin and eventually settled on a small Brookfield farm (section 5). Several years later, their son Abraham purchased a 115-acre Brookfield farm (section 8). Family members posing in front of the newer Basting home, from left to right, are Abraham, Katharine, Walter, Magdalena (mother), George, Abraham Jr. (father), Raymond, and Albert. (Courtesy of Patricia Basting.)

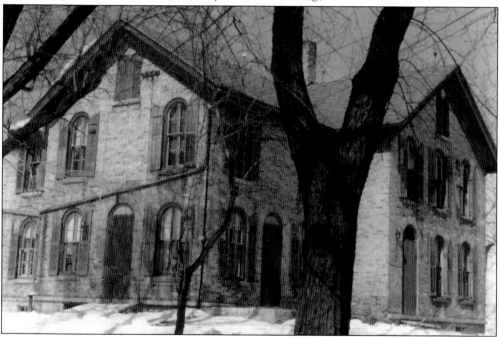

THE BASTING HOME, 1986. Built in about 1870, the outstanding design and construction of the Basting home (above) has been described as "Italianate cream city brick." Cream city bricks were a light yellow-colored brick made from clay found in Milwaukee along the banks of the Menomonee River and Lake Michigan, giving Milwaukee the nickname "Cream City." By 1940, son Albert was running the farm after his father, Abraham Jr., had retired. (Courtesy of Arline Kirkham.)

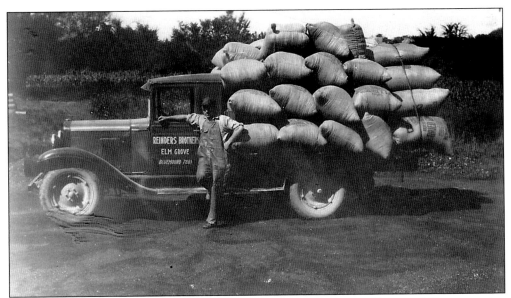

DELIVERING FEED, 1930. The Reinders brothers of Elm Grove are all set to deliver a portion of a 30-ton order of feed to the George Schneider farm in New Berlin. All the farmers in the area knew that the trademark "Old Elm Feed" meant that it was from the Reinders mill. George Reinders remarked in 1976, "We knew every farmer around in a 30-mile radius of Elm Grove." (Courtesy of Dorothy Haley.)

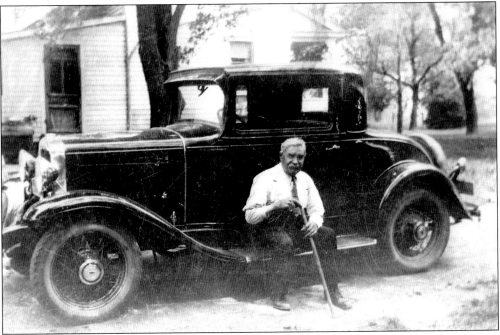

A LIBERTY MOTOR CAR, C. 1933. The Liberty Motor Car was manufactured in Detroit from 1916 to 1924. In 1924, the company was acquired by Columbia Motors. In this view, retired farmer Charles Bolter of Brookfield (section 16) proudly poses in front of his Liberty Motor Car after taking what was perhaps the longest trip in his lifetime, driving from Brookfield to visit his sister Alice Behling in Janesville. (Courtesy of Evelyn J. Nicholson.)

HEAVY BAGS OF GRAIN, 1920S. In 1968, Chester Wilson and Roy Aitken of Brookfield (section 30) recalled, "The bags of grain were carried one at a time on the shoulders of the men to the barn where it was dumped in the bins of the granary. Chet Wilson said that some of the men's shoulders in later life were lower as a result of carrying heavy grain bags." (Author's collection.)

OVERALLS AND STRAW HATS, 1933. Posing for a photographer while working on the John Simon farm (section 35), from left to right, are brothers Allen Simon, Earl Simon, Gil Dechant (cousin), John Simon Jr., Francis Simon, and John Simon Sr. (father). (Courtesy of Gil Dechant.)

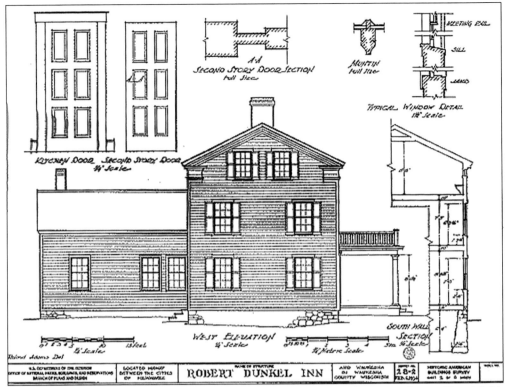

ROBERT DUNKEL HOME, 1932. Alexander C. Guth wrote, "The entire house [Brookfield, section 27] leads one to believe that it is the work of a craftsman who was trained in the eastern states and then immigrated west to the northwest, where he pursued his craft as he did in his original home state. The date of the building is approximated as the early 1840's." Shown above is a drafted side view of the Robert Dunkel home, and below is a photograph of the structure. Now referred to as the Dousman Stagecoach Inn, the building is preserved and maintained by the Elmbrook Historical Society. (Courtesy of Historic American Homes Survey, Library of Congress.)

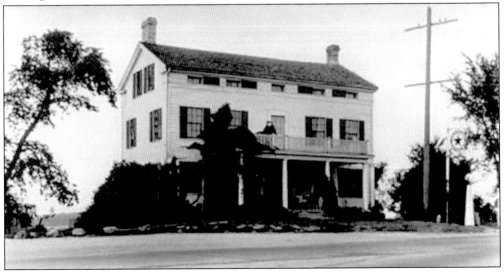

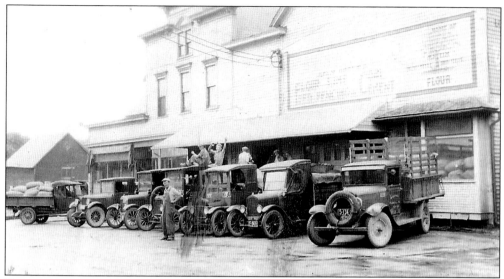

THE END OF PROHIBITION, 1934. The 21st Amendment, ratified on December 5, 1933, officially ended Prohibition. Following ratification, Brookfield-area farmers park in front of Reinders mill at Elm Grove, ready to unload large bags of homegrown barley (sold at $1.23 to $1.28 a pound) to be shipped by train to Milwaukee's world-famous breweries, including Schlitz, Miller, Blatz, Gettleman, and Pabst. The breweries were able to get back to the business of brewing beer after a 13-year hiatus. (Courtesy of Dorothy Haley.)

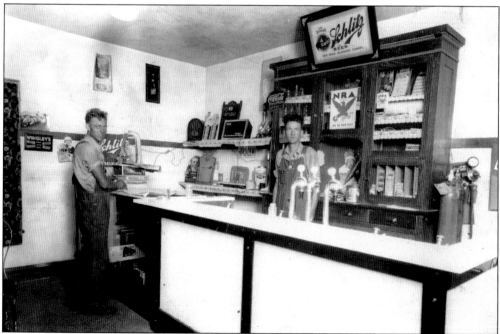

WALTER BASTING'S TAVERN, 1934. After selling soft drinks, cigarettes, ice cream, and Wrigley's gum, Walter Basting (behind the bar), whose tavern was located at what is today's southwest corner of Brookfield Road and Capital Drive, once again promotes and sells Schlitz. Beer was a beverage always enjoyed by Brookfield's predominate German population—Prohibition or not. (Courtesy of Patricia Basting.)

PICKING SWEET CORN, 1934. Mamie Bolter is seen picking sweet corn out the family's large garden on the August Bolter farm in Brookfield (sections 20 and 21). There may be more truth than one can really appreciate today to the old expression, "a farmer worked from sun to sun, but a woman's work is never done!" (Courtesy of Evelyn J. Nicholson.)

RAKING STRAW, 1935. Paul Brojanic (left) and his son John are seen raking straw from a small pen on the family farm in Brookfield (section 22). Keeping pens clean, picking rocks out of fields, cleaning out corncribs, and other such tasks was among the more mundane work Brookfield farmers found themselves doing on a daily basis. (Courtesy of Ann Pichler.)

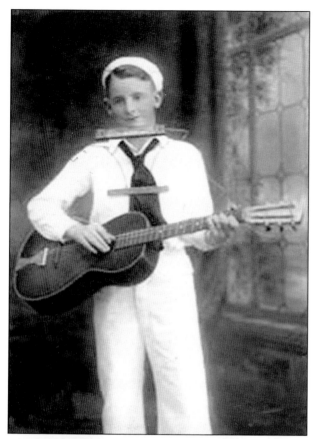

INVENTOR OF THE ELECTRIC GUITAR, 1936. Les Paul, born in 1915, has been acknowledged worldwide as the inventor of the electric guitar. On November 7, 2008, the Associated Press reported, "Paul remembers the moment when inspiration hit. He was playing at a barbecue stand somewhere between his hometown of Waukesha, Wis. and Milwaukee when a man told him his guitar wasn't loud enough." That barbecue stand was William Landsburg's stand (below), located in Brookfield at Goerke's Corners (section 30). Paul began playing acoustic guitar at a very young age (left) but continued to develop the electrification of his sound. Finally in 1952, Gibson introduced the Les Paul electric guitar model, and rock and roll has not been the same since. (Left, courtesy of Waukesha County Historical Society and Museum; below, courtesy of Elmbrook Historical Society.)

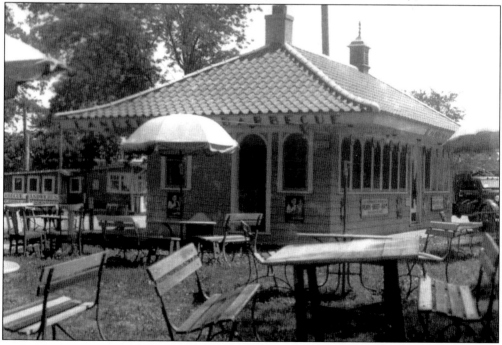

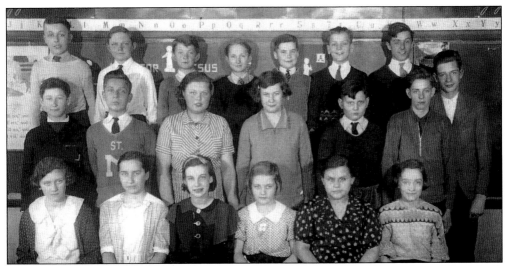

ST. MARY'S GRADE SCHOOL, 1935. Here are the seventh and eighth graders of St. Mary's Catholic Grade School at Elm Grove for the 1934–1935 school year. Seen from left to right are (first row) Lucy Marks, Mildred Rademacher, Betsy Rohr, Ruth Reinders, Jane Svehlek, and Catherine Sanders; (second row) Bob Witterholt, Joe Ramstack, Catherine Bobrowitz, Barbara Becker, Bob Jaques, and Gilbert Michel; (third row) Clement Reusch, Clarence Blaszyk, Paul Bobrowitz, Harold Gebhardt, Richard Smith, Robert Guiesell, Peter Boos, and Ed Frieberg. (Author's collection.)

BAG-CLOSING MACHINE, C. 1935. Pictured is the bagging process inside Reinders mill. First, grain drops down from a cleaner on the second floor into an "Old Elm Feed" bag with a scale reading its weight. Next, the bag on the belt goes through an automatic sealing machine. Lastly, oats are crimped on the second floor and dropped down into a sacker in the back room. (Courtesy of Dorothy Haley.)

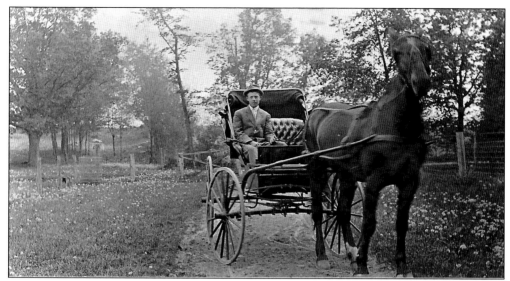

A HORSE AND BUGGY, 1939. William Phillips wrote on the back of this postcard mailed to his sister Helen (Phillips) Ramstack at Elm Grove, "A sure enuf of a reminder of the horse & Buggy times." (Author's collection.)

THE BLODGETT HOME, 1940. George and Mary Blodgett pose in front of their home on Bluemound Road in Brookfield (section 29). The *Milwaukee Journal* reported on March 31, 1929, "George Blodgett, who lives 12 miles west of Milwaukee, in the town of Brookfield, is gathering pails of sap from 165 maple trees he has tapped at his farm nearby. The sap is dumped into large milk cans and Mr. Blodgett drives his team among the trees to collect them." (Courtesy of Isabel Wray.)

Eight

THE END OF AN ERA

FARM AUCTION, C. 1945. During World War II, Brookfield began a dramatic transformation from a rural farming community to suburbia. Farms were sold off, and Albert Basting, like many farmers, turned over all his tools, livestock, and machinery to a local auctioneer to get what he could for them. By the 1960s, farming in Brookfield had nearly ceased to exist. (Courtesy of Al McGuire Collection, Elmbrook Historical Society.)

SUPPORTING THE WAR EFFORT, JULY 1942. When the country's supply of natural rubber was cut off from the Far East at the start of World War II, Pres. Franklin D. Roosevelt put out a call to all Americans to supply the government with their own used rubber that could be converted into synthetic rubber for the military. In this photograph, several young people from the town proudly pose in front a large pile of rubber boots that they had collected and piled high in front of F. Kehl's General Store in the village of Brookfield. (Courtesy of Arline Kirkham.)

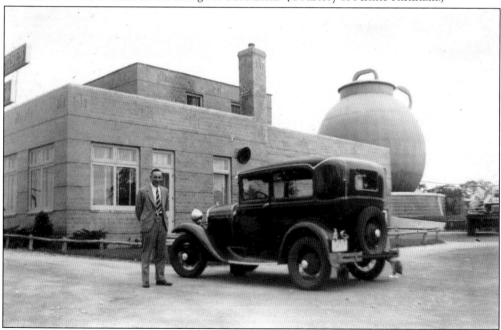

THE MILK JUG, 1946. Louis Kpvic poses in front of the Golden Guernsey milk jug on Bluemound Road (section 28). Inside was a large counter where patrons could order sandwiches, milk shakes, and ice cream. It became a popular hangout for teenagers during the 1940s. (Courtesy of John Schoenknecht.)

LOOKING BACK, AUGUST 20, 1956. On this date, August Bolter, seated, turned 100 years old. Behind him from left to right are Allie Behling, Freddy Behling, and Edie Behling. The family is looking through a large family photo album while reminiscing about earlier days. (Courtesy of Evelyn J. Nicholson.)

C. SANDERS AND SONS BLACKSMITH SHOP, C. 1934. William, Joseph, and John Sanders worked together in the old Sanders brothers' blacksmith shop. Joseph is seen here working on a grinder. On his right is a belt running a trip hammer. Despite all the modern technology the brothers brought into their shop, Joseph still proudly wears his Capewell and Northwestern Horse Nails cap, indicating that there was still plenty of horseshoing done in their shop. (Courtesy of Armella Sanders.)

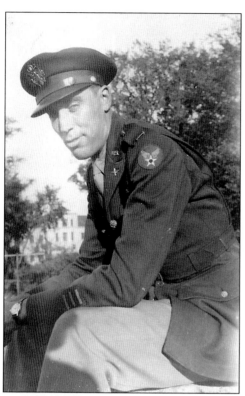

WORLD WAR II, C. 1945. Henry P. Nettesheim, a captain in the United States Army Air Corps, was the son of Conrad and Catherine Nettesheim of Brookfield (section 18). He was stationed in Panama from 1942 to 1946, serving as a communication officer for the Sixth Air Force. (Courtesy of Gene Nettesheim.)

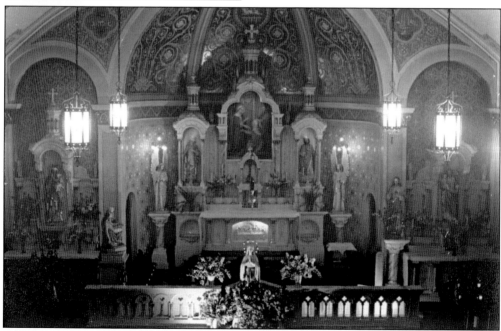

ST. MARY'S CATHOLIC CHURCH, 1947. St. Mary's Church at Elm Grove was built in 1921 to replace a parish that earlier stood on the property of the School Sisters of Notre Dame. A large number of local World War II veterans were married in this church between 1946 and 1955. (Courtesy of James and Elizabeth Potter.)

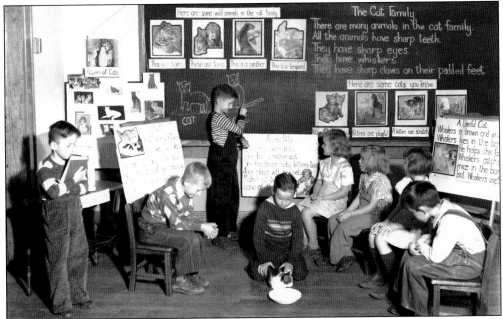

DIXON SCHOOL, 1952. The teacher of this first-grade class appears to be well prepared with plenty of graphics, pictures, sentences, projects, and even a live example for a lesson on cats. The Dixon School was located on North Avenue in Brookfield (section 23). While remodeling the building during the 1950s, workmen found a wall that revealed a written lesson dated 1882 under a slate blackboard. (Courtesy of John Schoenknecht.)

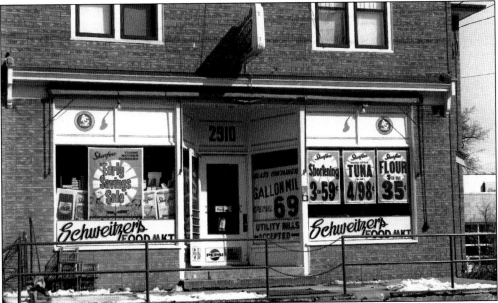

SCHWEITZER'S FOOD MARKET, C. 1952. Edward Schweitzer ran this grocery in the village of Brookfield (section 17) at a time when there were no more than three groceries in the entire town. This was a period when the town was still very rural and the majority of local farm families grew, preserved, butchered, and cooked their own foods right on the farm. (Courtesy of Arline Kirkham.)

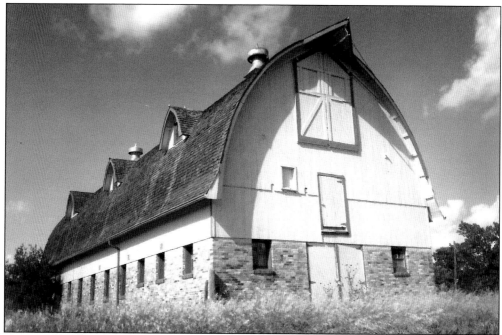

BROOKFIELD'S GREAT DAIRY BARNS, 1968. This architecturally significant dairy barn on the R. J. Kieckhefer farm (section 20), built in 1929, was just one of hundreds of wonderful barns that once stood large and proud in Brookfield. (Courtesy of Arline Kirkham.)

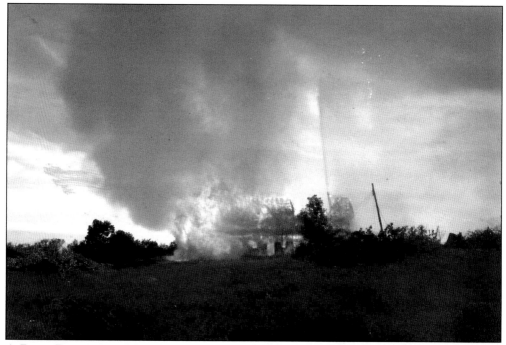

A BARN BURNING, 1968. The day the fire department burned down the Kieckhefer barn to make way for residential development, Arline Kirkham, a longtime Brookfield historian, grabbed her camera and took several shots of the barn's demise. (Courtesy of Arline Kirkham.)

THINKING THINGS OVER, 1982. In this image, Walter Mitchell sat down on an old rock on the family farm (section18) as if reflecting on his life's journey. In 1972, he wrote, "We managed the home farm—raised registered Holstein cattle—sold seed stock to three foreign countries and nine states besides local customers." (Courtesy of Evelyn J. Nicholson.)

BROOKFIELD'S LAST FARMER, 1998. During the summer of 1998, the *Milwaukee Journal Sentinel* wrote a story about Gil Dechant titled "Brookfield's Last Farmer." Dechant, then 81 years old, did not want to give it up. It was a life he knew and loved. This image of the town's last farmer might be a good way to end this account, which was singularly compiled as a means of acknowledging and honoring the town's old-timers. (Courtesy of Gil Dechant.)

Discover Thousands of Local History Books
Featuring Millions of Vintage Images

Arcadia Publishing, the leading local history publisher in the United States, is committed to making history accessible and meaningful through publishing books that celebrate and preserve the heritage of America's people and places.

Find more books like this at
www.arcadiapublishing.com

Search for your hometown history, your old stomping grounds, and even your favorite sports team.

Consistent with our mission to preserve history on a local level, this book was printed in South Carolina on American-made paper and manufactured entirely in the United States. Products carrying the accredited Forest Stewardship Council (FSC) label are printed on 100 percent FSC-certified paper.